FEARLESS
PHOTOGRAPHER

Portraits

Charlotte Richardson

Course Technology PTR
A part of Cengage Learning

COURSE TECHNOLOGY
CENGAGE Learning™

Australia, Brazil, Japan, Korea, Mexico, Singapore, Spain, United Kingdom, United States

COURSE TECHNOLOGY
CENGAGE Learning™

Fearless Photographer: Portraits
Charlotte Richardson

Publisher and General Manager,
Course Technology PTR:
Stacy L. Hiquet

Associate Director of Marketing:
Sarah Panella

Manager of Editorial Services:
Heather Talbot

Marketing Manager:
Jordan Castellani

Project Editor/Copy Editor:
Cathleen D. Small

Technical Reviewer:
John Harrington

Interior Layout:
Jill Flores

Cover Designer:
Mike Tanamachi

Indexer:
Larry Sweazy

Proofreader:
Melba Hopper

For product information and technology assistance, contact us at
Cengage Learning Customer & Sales Support, 1-800-354-9706

For permission to use material from this text or product, submit all requests online at **cengage.com/permissions**. Further permissions questions can be e-mailed to **permissionrequest@cengage.com**.

All trademarks are the property of their respective owners.

All images © Charlotte Richardson unless otherwise noted.

Library of Congress Control Number: 2011923901

ISBN-13: 978-1-4354--5824-6

ISBN-10: 1-4354-5824-9

Course Technology, a part of Cengage Learning
20 Channel Center Street
Boston, MA 02210
USA

Cengage Learning is a leading provider of customized learning solutions with office locations around the globe, including Singapore, the United Kingdom, Australia, Mexico, Brazil, and Japan. Locate your local office at: **international.cengage.com/region**.

Cengage Learning products are represented in Canada by Nelson Education, Ltd.

For your lifelong learning solutions, visit **courseptr.com**.

Visit our corporate Web site at **cengage.com**.

Printed in the United States of America
1 2 3 4 5 6 7 13 12 11

John

The circles of confusion seem farther away now—or is it just our age?

Cras amet, qui nunquam amavit, Quique amavit, cras amet.

Words of wisdom for my girls—avoid disappointment and future regrets by heeding the following advice:

Always flush with your foot.

Only believe in what you cannot see if it makes you happy.

Question everything at least once.

Trust your mother.

Don't marry until you've traveled to a different country. If you have to marry, elope.

I know everything because I've had 43 years' worth of mistakes to learn from.

The only person who can save you is you.

Your reputation is everything, good or bad, so choose wisely.

School sucks, but minimum wage blows, so work hard in school so you can coast later.

Your gut feeling is always right; learn to listen to it.

Boyfriends are disposable; babies aren't. Condoms are not negotiable.

Your mother loves you unconditionally.

Time does not stop for you, so enjoy every minute of your life.

When in doubt, ask your mother; I will never lie to you.

You get one body, so look after it.

You need health insurance.

Your past will shape your future, so don't waste the present.

You are beautiful.

Only give your love to those who return it and your number to those who are worth it.

Never lose control of your mind; drugs and alcohol are for losers.

Your father means well, but he is a man, and it's an unfair fight, so be gentle.

Always come home for the holidays, or I will hunt you down and humiliate you on the Internet with pictures from your baby album.

When I am old, don't treat me like an idiot, or everything goes to the animals.

Never make decisions on an empty stomach.

I love you.

Acknowledgments

This book would not have been possible without the support and strong-arm tactics of friends and family (and more than one stranger) who stepped forward to be photographed. I would also like to thank my editor, Cathleen Small, who shepherded me through the process to make my thoughts more clear and concise, and who Americanized my grammar, much to my horror. Thanks go to Mark Suban of Nikon for lending me equipment I needed for this project, which, in turn, I couldn't live without and ended up buying: Curse you, Red Baron! To Lindsay King, for being the über assistant who gets my attention to detail. To my mother, for our first Box Brownie 40 years ago and for sending the film out for development in the little envelopes that magically returned with prints and free film. Lastly, to John Harrington, who believes that once you hit the keyboard with your head to press "send" on your book contract, you are contractually bound, and who will cheer you to the finish line with chocolates and moral support, even when there are only 24 hours in a day and you need 25.

About the Author

Charlotte Richardson has been a professional photographer for almost 20 years, on both sides of the Atlantic—the United Kingdom and the United States. She has worked with presidents and other heads of state, as well as your everyday mom and pop. From the White House to their house, she is able to put her subjects at ease with a sense of humor and a keen creative eye. She believes strongly that every portrait is an opportunity to delve into the depths of the subject's character and produce a timeless moment. Her portraits reveal the innermost hopes and desires of everyday people to challenge our preconceived ideas about what the portrait market today can bear. Charlotte resides in the Washington, DC, area with her children and spends her free time sleeping.

Contents

Introduction

Being a photographer means you are creative by default, even if you don't see it that way. Many times, we find ourselves stuck in a rut and going through the motions to earn the almighty buck because we all have to pay the bills. When we first picked up a camera, many things happened—most of them magical—and we were out to make art, change the world, be someone. The reality hit hard and fast, and soon we found a way to make a living doing what we loved, but not necessarily living the dream. Photography has changed so rapidly in the past decade that many of us spend hours just trying to understand the latest software and techniques, and we have little or no time to exercise the creative muscle—caving to clients' desires and whims, unable to incorporate our own burning desires for brilliance.

Well, enough, I say! Join me on a quest, and together we will reignite those creative impulses and forge ahead as if it were the first time all over again. Okay, in reality, I'm going to do all the work, and you are going to pull up a chair and laugh out loud as I get down and dirty. First, let's be clear: Everything I'm going to show you is achievable by the common man. There will be no huge financial outlay, no expensive models, no jet-setting to exciting foreign locales. No, that's the next book—this one is with real people. If you have a camera and some drive, you will be off and running before you know it.

I've had a shot list in my head for as long as I can remember. The list is composed of people I know and some I don't, but always in exciting scenes percolating in my brain. It's common to see glossy spreads in high-end magazines showing some celebrity in a ridiculously fabulous pose, surrounded by wild animals and nudes. How many times have you thought, "Well, if I could work with that person, I could do that, too"? Really? Where's the fun in that? There are a limited number of celebrities out there to work with, but there's a never-ending supply of normal folks who need a good portrait. "Ha!" I hear you say. "The normal folks would never go for it." Really? Then you've never been to a wedding with disposable cameras on the table! You would be amazed by what Great-Aunt Edith will do when no one is looking. Case in point: Set up a camera in your living room and ask everyone who walks into the house to shoot a self-portrait and leave the room. I guarantee they will not be sitting static in the chair, grinning. Everyone has a little exhibitionist in them, desperate to get out.

Every little girl wants to be a princess and every boy a hero. Everyone wants to look good, feel larger than life, and be treated like a star. All you have to do is drag it out of them. Now, there are a million ideas out there, and some of them have been done before—but not by you, and not with your subjects. So don't second-guess yourself or talk yourself out of it; be brave and soldier on.

First, make a list—as ridiculous as it sounds, it all starts with a step. The list gets the ideas out there and lets them breathe. Once they are free, they are easier to talk about. When you ask your mother to get in the bathtub full of bubbles with a martini, it will make sense to her because it's on your list—trust me on this one. As you go through the list, the ideas will become clearer and more achievable. Also, when you meet the right person to pair up with a shot on your list, you will know instantly that he or she is

the right person. I have always wanted to shoot with fire, and when I met the perfect couple for that, I knew right off the bat that they would be perfect. When I pitched the idea to them, it was as if they had been waiting for me to come along. Sometimes you need to make the shot happen just so it doesn't fade away and never see the light of day.

Here's a funny story. About 10 years ago, the Potomac River in Washington, DC, froze solid for weeks. The ice was so thick that it formed huge glaciers, and as the ice floe moved, it piled up like mountains on the river. I was mesmerized by the process, and as the ice pack grew taller and thicker, I had this crazy idea. I wanted to put a nude woman on the ice and shoot a black-and-white image. It made perfect sense to me, but everyone I talked to thought I was crazy. No sane person was going to walk out on the ice, climb the glaciers nude, and pose for me. The risks were too great, and it was well below freezing with the wind chill. I knew the opportunity probably would never present itself again. So, not to be undone, I asked a fellow photographer to shoot the image with me as the model! The image was made, and even though I didn't take it, I had the satisfaction of knowing my vision had come to life. Years later, I got a call from the photographer, asking whether I would sign a model release so the image could be used as a book cover for a novel called *Ice Maiden*. Eureka, my work lives on. The point is that you need to believe in your ideas and make them happen, even if they're not perfect the first time around. You are perfecting your craft and gaining the experience and confidence to move your work into the mainstream, which translates into making a living doing what you love.

So let's talk about being fearless. It doesn't always mean putting yourself in a dangerous spot; it means pushing yourself outside of your comfort zone. It means trying something different that is not in your normal skill set. It means facing your shortcomings and working with them and around them to come out the other side with a different outlook on your abilities and talent. There is nothing you cannot do.

If you doubt yourself and are in need of inspiration, look no further than *American Idol*. Love him or hate him, everyone remembers the guy who could not sing: William Hung. Glued to the screen, unable to look away, America dropped its collective jaw as he belted out the first notes. "No way!" you all screamed. Did Mr. Hung disappear into obscurity? No—he took his bad self to the nearest recording studio and laid down some sweet tracks. What's the point? The point is that there is a market for everything and everyone in this world. Even though one person might not see or love your vision, someone else will. Pushing forward and believing in yourself is 99 percent of what is required to succeed. People are drawn to people with a purpose and a vision.

As we work through the chapters in the book, it will become apparent that "fearless" has many different connotations. I will photograph subjects in difficult and risky situations that you will be able to identify right away as a little scary, but the real fun begins when we photograph things that make us uncomfortable! What does that mean? It means facing realities that make your stomach fill with butterflies at the thought of being in the presence of these people.

Technical Notes

A quick note about Photoshop and similar software: I firmly believe in doing as much as you can on the shoot and through the lens. Don't rely on the computer to fix your mistakes; take the time to think it through, because nothing is worse than sitting in front of the computer for hours working on things you could've taken care of in five minutes onsite. As we move through the pictures, I will tell you what, if anything, was done in post-production. Photoshop is an incredible tool, but don't overdo it! Real is always better unless you are going surreal—then go for it! Every picture has been sharpened for printing in this book, and to understand why, you should read *Real World Image Sharpening with Adobe Photoshop, Camera Raw, and Lightroom* (Peachpit Press, 2009) by Bruce Fraser and Jeff Schewe. I will tell you as much as I can about the equipment I used and the lighting setup, but in this age of digital photography, where you can preview instantly, the f-stops and shutter speeds are not as important as your own personal vision. In short, don't get hung up on the exposure I used; just use the information as a point of interest and meter yourself.

Part I

Children:
Herding Feral Cats

If you are one of those people who loves watching the kids who scream when they sit on Santa's lap at the mall, then this chapter is for you. I have always loved screaming-kid pictures because they show a real moment in a child's life. How many trite pictures of children in soft light, wearing their Sunday best, does the world need? There is, of course, a place for that kind of portraiture on the dresser or desk of every doting parent, but I prefer a real expression of the child's personality.

As a child grows, you have so many opportunities to capture different looks and moods—the fun never ends! And if you actually ask a child how he or she would like to be photographed, you will find that kids have many ideas, and most of them are out of left field. Younger children are the most fun, as they are influenced by their older siblings and are keen copycats when it comes to everything they see on television.

When photographing children, I always like to involve them in the process and really listen to everything they have to say. But keep in mind that you have a narrow window of time with children under the age of about six, as tiredness and hunger can set in quickly. Make sure you shoot around their schedule, not yours, or the final outcome will not be pleasant.

Bribery is key, so always bring small treats or toys that children can find in the camera bag, just peeking out the top! If possible, I like to shoot at children's homes so they have every-thing close at hand and will feel comfortable. Parents are always welcome, but bear in mind that the child will always look at the parent unless the kid is a real ham, so have the parent stand where you want the child to look. Depending on the age of the child and the mood of the picture you are trying to portray, music can add a lot of fun to the shoot.

NOFEAR

Sometimes having a camera bag that is actually a toy bag is a good idea. In it, you can keep various noisemakers, sparkly things, and other eye-catching trinkets that will get a child's attention.

"Children are completely egoistic; they feel their needs intensely and strive ruthlessly to satisfy them."
—Sigmund Freud

1 Large and in Charge at Five:

Chloe Alyce and Lucky

Chloe Alyce had older sisters, so she wanted it all—makeup, jewelry, and her dog with a pink mohawk. Who am I to argue with that? A child like Chloe is the best kind of subject, because she has the personality to carry off the shot. Chloe had so much fun getting ready, but she was only five years old—so we had to be ready when she was, because timing is everything with small children.

I wanted a fun look for this shoot, so I chose a blue background and a three-light setup. For those of you who balk when someone asks whether you have a studio, take a deep breath and say, "Yes, yes I do, and it's coming to you." You need to adapt to any space when working with small children, and they do much better on their own turf. I moved some furniture and set up two umbrellas and a backlight to add a glow behind Chloe.

"You need to adapt to any space when working with small children, and they do much better on their own turf."

I used a piece of the backdrop paper to make a small cover to hide the light on the ground from the angle of the camera; it took seconds on site. This is a great way to save time later in post-production, because otherwise you would have to use Photoshop to digitally remove the light later. Music is a must, as it puts the subject more at ease when you want a fun shot.

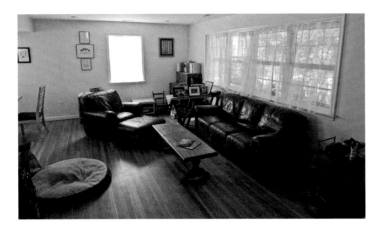

This is the space we had to work with for our studio setup.

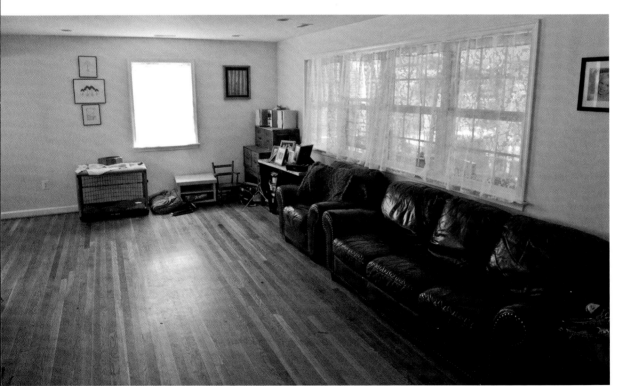

Carefully moving the furniture around gave us a nice working space in the living room.

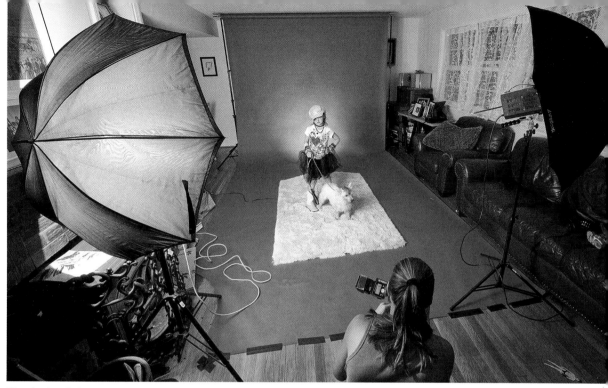

Here's the finished setup, which has three lights total. There are two umbrellas with silver reflective linings, a bright blue background, and a pink rug. You can do this! Remember to use gaffer's tape or some other heavy-duty tape to secure your backdrop and hide cords that would be visible in the photo; mine are under the rug.

Homemade camouflage for our background light saved time later in Photoshop.

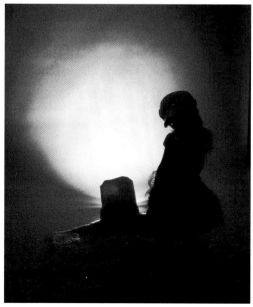

This is the effect the background light has—an extra element of drama.

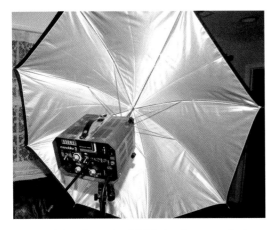

I used lights from the 1990s to show you that you can make a great picture with older technology. Don't get hung up on the cost of top-of-the-line lights if you are just starting out. These lights have built-in slave sensors (as do almost all lights today), so I triggered them with my SB 800 set to 1/8 power in Manual mode (which triggers the strobes but does not affect the lighting on Chloe).

After adding pink food coloring to Chloe's dog's head to fashion the pink mohawk, we were off and running. (For those who may be concerned, the food coloring was organic and washed out easily. Chloe's dog, Lucky, was more than happy to have all the attention.)

It is imperative to connect with small children, so have everyone stand behind you to focus the child's gaze. Children are easily distracted, and you want them looking in your direction. You've heard the saying, "Never work with children or animals"—well, I say that's what makes it fun! You just have to be organized.

I had one person call Lucky's name as I concentrated on Chloe. I will undoubtedly say this more than once, but it bears repeating: You *must* talk a lot and keep it upbeat to hold a child's attention. Even a child who wants her picture taken is over it in about 10 minutes! It becomes all too much like hard work for the child, and she's over you.

With this in mind, shoot fast and furious and use an animated voice. Tell them they are awesome, and they will love you—until they are done. Then, if you feel you still don't have the shot, take a break and bribe them with candy and toys! If they start to flag, get them to jump or stick out their tongue—it will make them laugh and break things up.

NO**FEAR**

Don't be afraid to use candy or toys to encourage a child who has decided she doesn't feel like shooting anymore!

Primping Lucky included a bath and food coloring for his mohawk, which was very easy to do.

"Talk a lot and keep it upbeat to hold a child's attention."

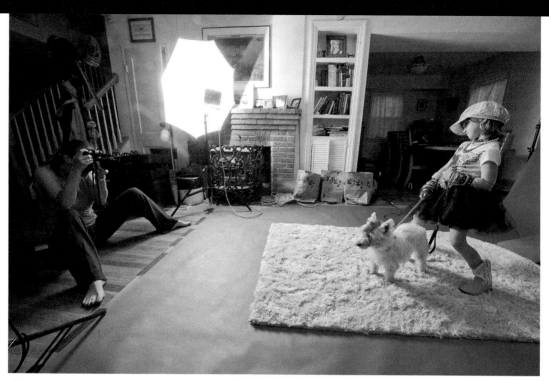

Engaging Chloe and not being afraid to get on the floor—there is no standing on ceremony with kids!

Shake it up and see what you get. Chloe lasted just under 20 minutes, and I got 56 frames. That's all she was willing to give before the TV was more important than me!

If you don't have clips, get some now! I never leave home without them; they will save you time and time again. Here, an oversized belt was reined in by my faithful clip. You can also see clips keeping the backdrop from unrolling at the top of the background stands in previous pictures.

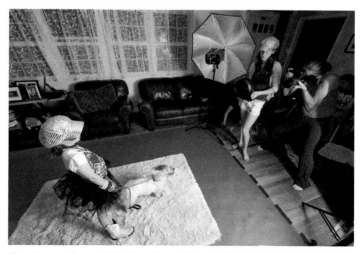

Family members behind me keep Chloe's attention in the right direction. The fan makes Chloe feel special, and she acts like a rock star.

Shooting young children is the fastest way to make you rethink everything you know about photographing kids. Every time I hear someone say, "Never shoot down on a child; it makes them look small," I laugh out loud. They *are* small, and sometimes that makes for a great picture. Forget the tried-and-tested ways to make portraits and go with the moment. It will set you apart from the pack.

"Shooting young children is the fastest way to make you rethink everything you know about photographing kids."

Shooting down on a child can capture a timeless moment.

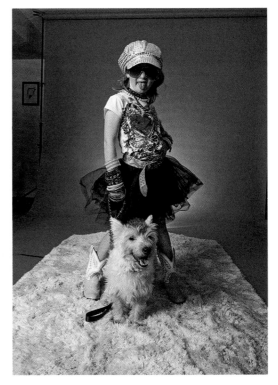

(Above) Getting Chloe to loosen up! (Facing page) The finished portrait of Chloe showing just the right amount of attitude.

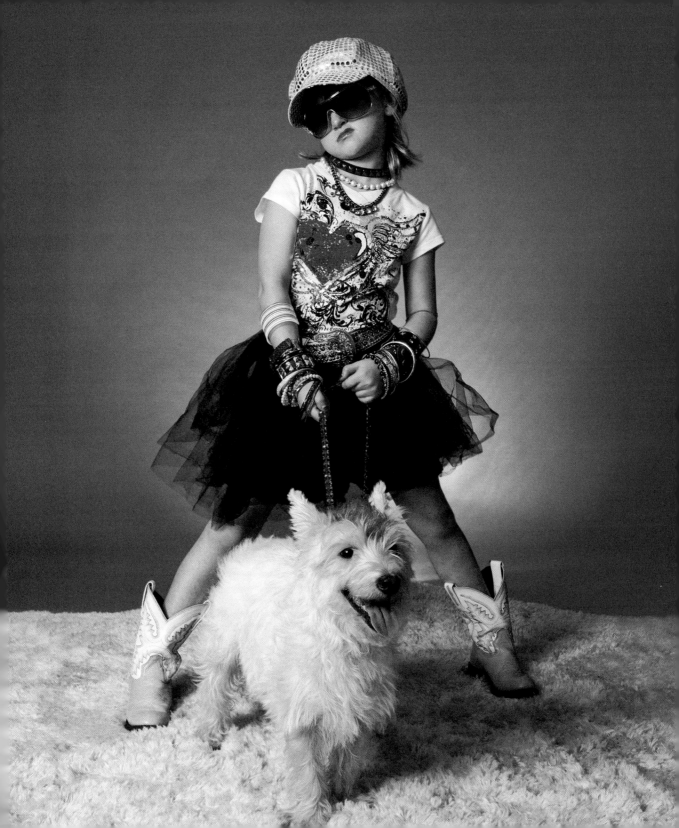

Equipment Used

- Nikon D700 camera

- Nikon 24-70 f/2.8 lens

- Balcar Monobloc 2 strobes

- White Lightning 600 Monobloc strobe

- Nikon SB-800 strobe

- Westcott 32-inch silver reflective umbrellas

- Savage 9-foot Studio Blue backdrop

Photoshop Modifications to Final Image

- Removed the catch light in Chloe's sunglasses using Patch tool.

- Removed the end of the belt using the Clone tool.

- Adjusted the color in Lucky's mohawk using hue and saturation adjustments in the red channel.

- Adjusted the color in Lucky's fur by decreasing the saturation in the stained areas around his mouth.

- Removed the hair protruding into Lucky's eye using the Clone tool.

- Removed the scuffmarks on Chloe's boots using the Clone tool.

- Extended the rug using the Clone tool.

"*Consulting the rules of composition before taking a photograph is like consulting the laws of gravity before going for a walk.*"
—Edward Weston

2 Sisters: The Pillow Fight

Shooting more than one person in a portrait is a challenge, but shooting three children—ages 18 months, 6 years, and 10 years—while bouncing on trampolines and hitting each other with pillows adds a whole new level of difficulty. (That's putting it mildly.)

First, you have to be realistic—the 18-month-old will not have the attention span of the older sisters, and they, in turn, will probably take things too far when given the opportunity to hit each other without fear of reprisal. As such, that's pretty much what happened on this assignment.

I love the idea of a pillow fight, but I want it all—feathers, action, kids, and perfect light. (I sense you are rolling your eyes….) I had three willing subjects and a great location, so I just had to pull it all together.

I chose to shoot outside for two reasons. First, it was going to be very messy, and cleanup would be difficult. Second, I needed a high window from which to throw feathers. So I chose the side of the family's garage, which had a perfect window dead center on the side of the building.

The outdoor location that we would convert to our set.

NOFEAR

When you're looking at a messy shoot, consider moving it outside. In many cases, it's relatively simple to create the feeling of an indoor shoot outside.

Next, I needed supplies, so it was off to the thrift store for feather pillows. For this type of shoot, don't be tempted to get anything that says "down"—it's too light and fluffy, and it sticks to everything. (As an added bonus, feather pillows are much less expensive than down ones.) Look at the label and choose white goose or duck feathers, if possible. I found four pillows for less $10, and two of them were perfect and gave me more than enough feathers.

Cutting open the pillows to get the feathers out.

I coordinated the older children's pajamas and gave the baby something different to help her stand out and not get lost in the mix. To a certain extent, I had to re-create a bedroom outside, but I wasn't too concerned with the details. I hung a red backdrop on the wall and placed two small exercise trampolines on the ground. Next, I used a camera case as a platform for the baby. I wanted to give the illusion of height, but I didn't want the baby falling off anything that was bouncing. I could have used a mattress, but cost, bounce, and height were considerations for the youngest member of the shoot. The whole setup was covered with sheets to make it look like a bed.

Lighting was crucial. I was worried about possible shadows from the feathers and separation of detail. Couple that with moving subjects, and I wanted a huge light. Lucky for me, such a monster exists, and it is so much fun to play with! (It also gets great satellite reception....) I'm referring to the Calumet 8-foot parabolic umbrella. Lots of light gave a nice, even exposure, so I didn't have to worry about that and could instead focus on my subjects.

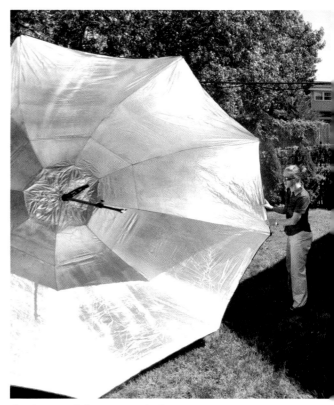

Getting the set ready, covering the trampolines, rolling out and taping the background, and then laying out the sheets.

Getting the 8-foot parabolic light set up.

Softboxes versus Umbrellas

There is much to be said about softboxes versus umbrellas. Umbrellas are generally easier to set up, while softboxes provide a soft, diffused light. From shoot-through translucent umbrellas to gold and silver reflected umbrellas, there are many choices to suit your creative desires. In the case of a large softbox, you get a very large, diffused light, and a large parabolic umbrella allows you to have not only a very large, focused light, but also a higher-contrast light, rather than a soft, diffused light.

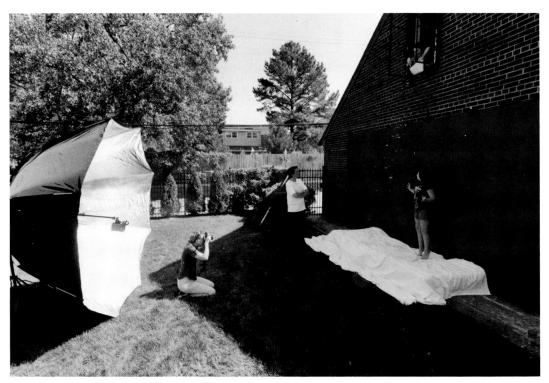

The side view of the setup and an early test.

NOFEAR

Don't be afraid to rent equipment that would otherwise be out of your budget. It's a great way to try it before you buy it, and for a few dollars, you can try out thousands of dollars of equipment.

When shooting any portrait that involves an energy component, you have to go over the poses and ground rules first. These girls were eager to start hitting each other, so we simply outlined acceptable points of contact and that there would be no hitting in the face. Alas, that fell on deaf ears!

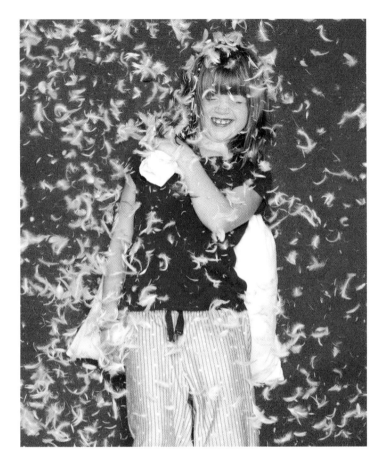

A close-up of our six-year old subject, Diana, made for a pleasing solo portrait.

We tested the rate of feather fall and added a fan to help blow the feathers in the right direction. The trampolines were great for giving the girls the feeling of being on a bed, but they quickly tired from bouncing. As predicted, the baby was more interested in looking at the back of my camera than in sitting for the shot. So we shot her separately, and with the magic of Photoshop, we added her into the best shot.

"When shooting any portrait that involves an energy component, you have to go over the poses and ground rules first."

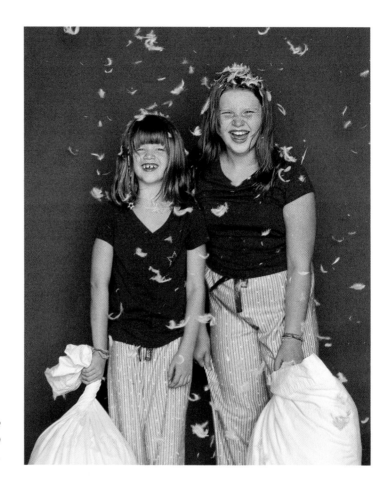

The 10-year-old and the 6-year-old getting warmed up to the idea of feathers falling.

This is a fun, high-energy shoot that nearly all children want to do, so don't be afraid to suggest it when you're offering up portrait ideas. Just be prepared for the massive cleanup afterward!

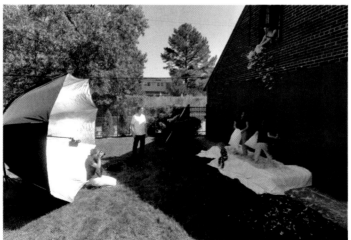

(Left) The shoot in action, from the side. (Facing page) The final image.

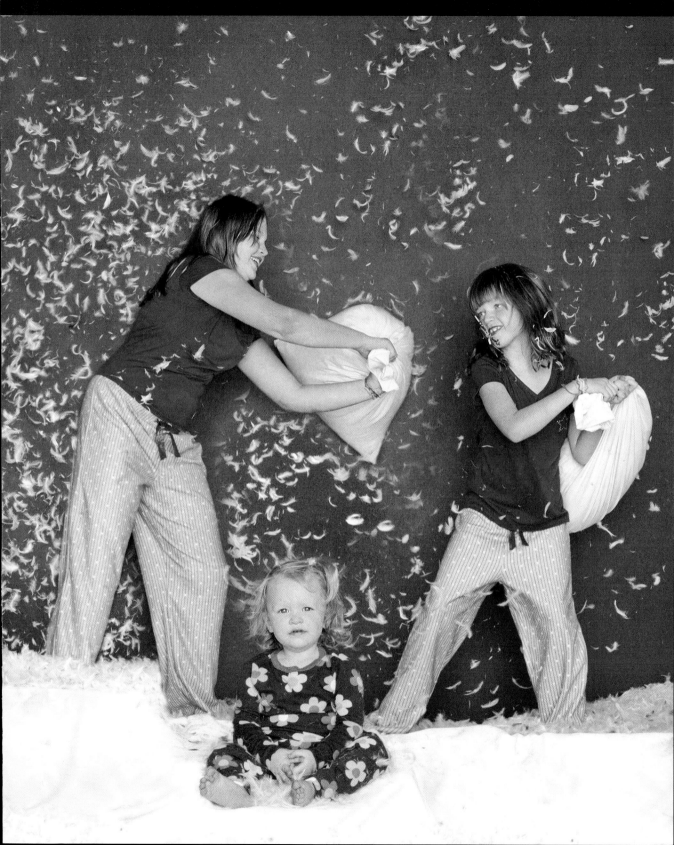

Equipment Used

- Nikon D700

- 50mm f/1.4 lens

- Hensel Tria 3000 AS

- Calumet 8-foot parabolic umbrella

- 9-foot red seamless backdrop hung sideways

- Two exercise trampolines

- Three feather pillows and white bed sheets

Photoshop Modifications to Final Image

- Used three photos to make one.

- Dropped in baby using the Refine Edge tool.

- Added feathers to the bare spots.

- Combined the best action shots of the older girls using layers.

"*Life is pretty simple: you do some stuff. Most fails. Some works. You do more of what works. If it works big, others quickly copy it. Then you do something else. The trick is the doing something else.*"
—Leonardo da Vinci

3 Preteens:

Olivia and the Beach

The preteen years are a great age—not much attitude to speak of, but a whole load of enthusiasm and a willingness to try hard to get it right if fun is involved. So let's take every little girl's dream and add an interesting twist. All little girls dream of a big, white wedding and a handsome prince, but they lean further toward the dress and the party when they are young. So I had the idea to shoot Olivia in her mother's wedding dress—but to push it over the edge, we added a water element.

You have to know your subject, and Olivia loves the ocean—the bigger the waves, the better. So I did a little research to find the best location, and off we went!

I chose to shoot in Delaware, close to Rehoboth Beach, as there is an ocean and a bayside beach. This was key, as I wanted to shoot in daylight and at sunset. The ocean side would not give me the sunset, but it had great waves. The bay had the sunset, so timing was everything.

If you're lucky enough to live in the gulf area, this is not such a problem for you, and you can spend the day getting great shots. In this instance, I was lucky enough to shoot the weekend a hurricane was coming up the East coast, so the waves were stellar!

There are a few things to consider when you're shooting in the ocean with your clothes on. Perhaps surprisingly, the water isn't the biggest concern. Instead, it's the sand that gets churned up with the water and lodges itself in fabric, making clothing very heavy very quickly. When you're shooting kids, this means you need to keep it fun and have people on hand to haul them up when they are overwhelmed by the waves. Go over the poses and your expectations while you're on dry land, as the action happens quickly when you enter the water.

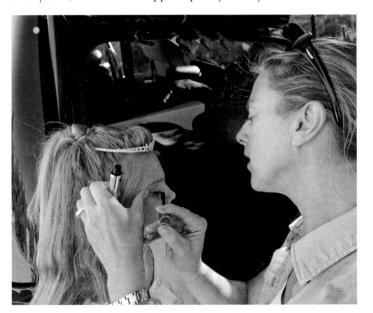

Working out of the back of the location vehicle, applying makeup.

"Go over the poses and your expectations while you're on dry land."

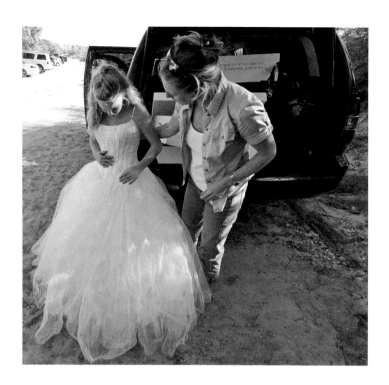

Getting dressed in public requires finesse.

My trusty clip adjusts the size of the dress.

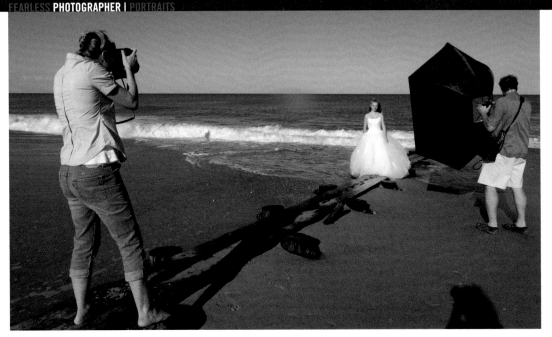

Olivia steps out onto wooden jetty to get started and comfortable.

I decided to shoot with one light in a large softbox and maybe a reflector if needed. I needed the light pretty close to the subject, and given that it was a windy day, I needed a strong grip on the light. The last thing you want is your assistant going down in the ocean with the high-voltage battery pack strapped to her back. If you're just starting out, and the word "assistant" seems foreign to you due to budget constraints, grab a friend—you do not want to be short-handed at the beach.

The portable lighting I was using has about a six-second recharge time, so I needed to time my shots around that. Knowing you will get one shot per wave makes for a high-energy shoot!

The location I chose had a nice wooden breaker that was the perfect place to start Olivia off gently, even though she would have jumped right in! This also gave me a firm footing to get my light right before getting wet. Make no mistake: On a shoot like this, you will get wet!

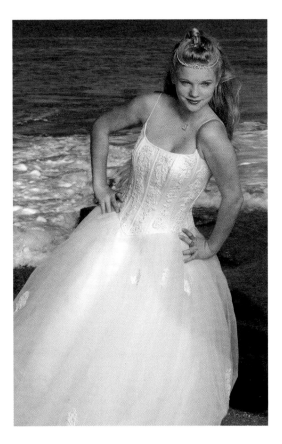

Still not wet, Olivia is full of attitude and having fun.

My assistant managed to use the softbox as a gobo for Olivia's eyes, as the sun was low in the sky behind me and directly in her eyes. This was a life-saver, because it was difficult to hold up a shade for her due to the wind.

Make sure you watch the waves coming in—look for the spot that gives you the best splash. The shape of the sea floor will determine your options for incoming waves.

Olivia was great, and we had worked out the best foot positioning to give her a firm grounding in the wake. She needed to brace herself against the force of the wave while looking regal and trying not to loose her tiara. So after a slow start, off we went for the real thing!

Gobos

A gobo, go-bo, or "go-between" is something that goes between (thus the name!) a light source and the area/subject being photographed. Sometimes it's a scrim or flag to block the light; sometimes it's a "cookie" to make the light look like trees or a window or even a logo projected on a wall. The idea is that if you need to modify the light falling on a subject, you use a gobo.

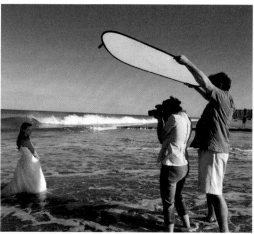

Using the translucent panel to shade Olivia.

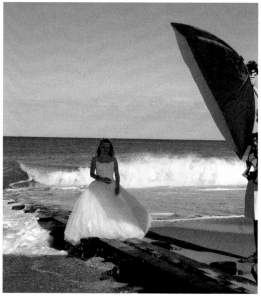

Using the softbox as a gobo to shade Olivia's eyes from the sun to prevent squinting.

NO FEAR

Be sure to talk to your subject for the entire shoot. It's hard work for the model, and you want it to remain fun!

By about the time the fourth wave hit Olivia, she was feeling the power of the ocean. You need to communicate the timing of the incoming waves so the subject stays focused and facing forward. If your model is constantly looking over her shoulder to see when the next wave is coming, you'll miss many moments.

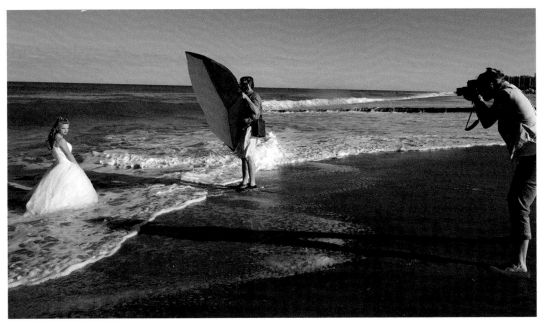

Entering the water backwards and being told when the next wave would come.

NO FEAR

When your subject is overcome by a wave and falls down, keep shooting! Some great shots are made during totally unscripted moments.

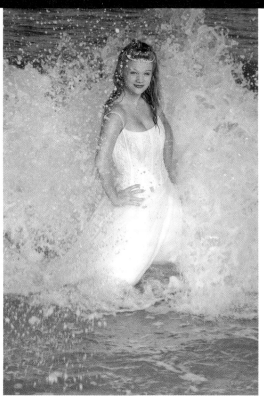

(Left) Dramatic wave action overpowers the subject and her expression. (Below) Down but not out. Keep shooting, as some off-the-cuff photos can be a lot of fun.

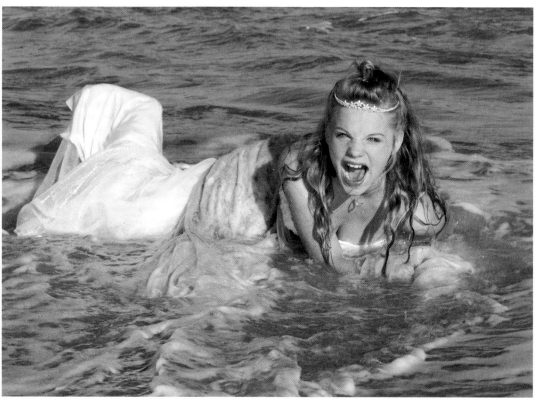

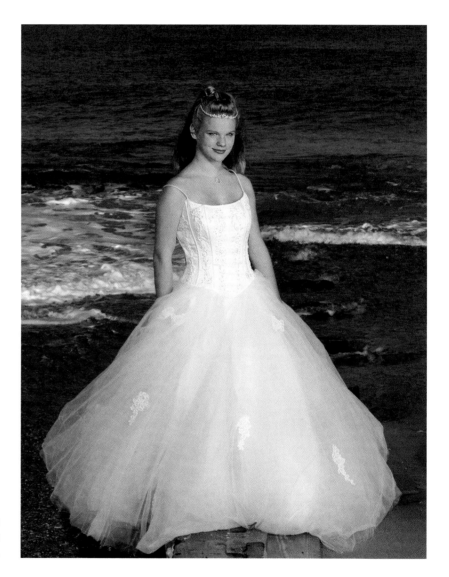

*A high angle
can remove the
horizon line.*

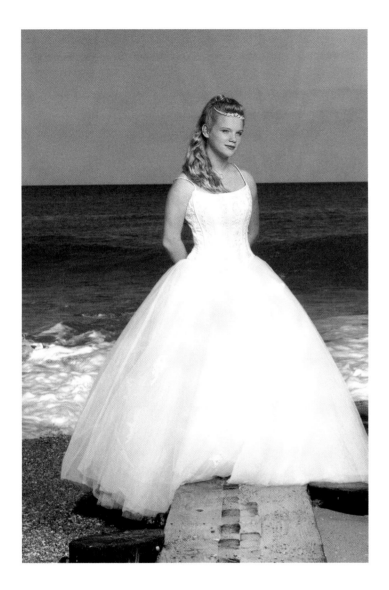

A low angle gives you a horizon line, so be cognizant of how that can affect the image visually.

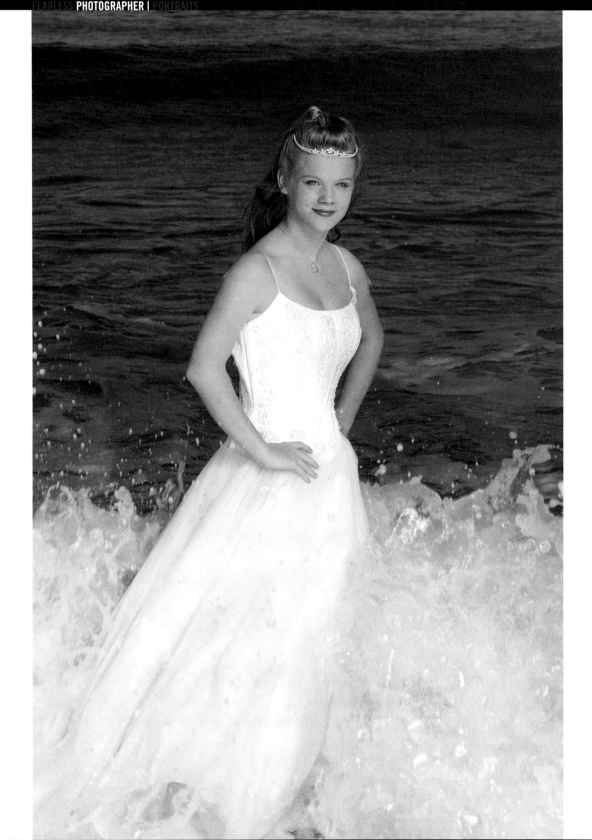

We spent about an hour on the ocean side, and then it was a short drive over to the bay for the sunset, which presents its own unique set of problems that come with shooting at the end of the day—time runs out quickly. Olivia had enough time to dry out and get a quick touchup, and then she was back in the water, waiting for the perfect sunset.

I've had my fair share of disappointments with sunsets—they can be tricky. You have no way of knowing whether it's going to be a good show or a mediocre event. Also, when the sun starts to put on its show, you have mere minutes to shoot before it is gone. You're trying to get the best from your subject while watching your background disappear before your eyes.

We went over a few poses, but this one was easier because there were no big waves to contend with—only the rapidly setting sun.

It's important not to lose your ambient light, so make sure your strobe is perfect and choose a nice, slow shutter speed to bring in the sunset and detail in the ocean. Here's a useful factoid: The sun goes down approximately every three minutes by its own diameter. In layman's terms, it's fast!

I wanted a different feel for the sunset shot—a little more high glamour with a fashion feel. The beach was more high energy, and the light was clean and bright. I moved the softbox around to create great shadow details, slightly off center. Before I knew it, I was done and heading home, exhausted! Fresh air will do that to you.

I had wanted a shot of Olivia with a lot of wave action behind her with lots of spray, but in the end I found that something in between made for the best shot. Besides, when dealing with an 11-year-old, your opinion ultimately is a moot point. She, of course, liked everything I didn't. Kids—whatever!

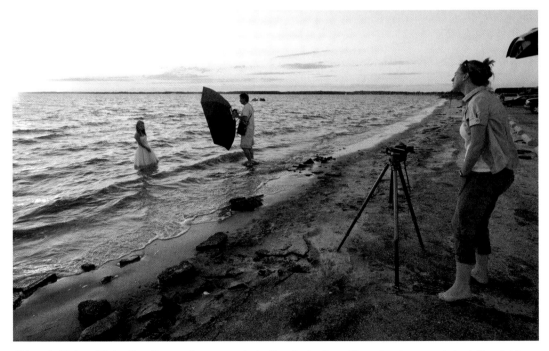

(Above) Giving Olivia direction as the sun sets to the desired position. (Facing page) Just the right amount of splash with a confident expression.

"When the sun starts to put on its show, you have mere minutes to shoot."

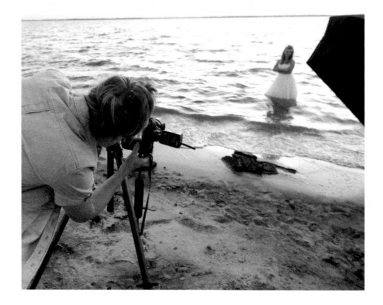

The view from behind the camera, also showing the PocketWizard on top of the camera.

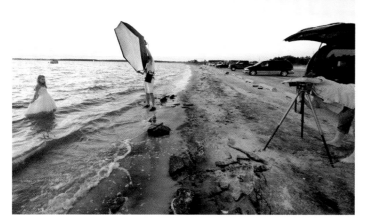

A second look at the lighting and subject setup.

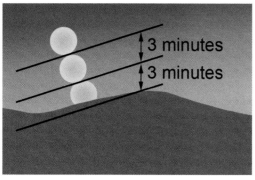

3 minutes

3 minutes

The sun goes down approximately every three minutes by its own diameter.

(Facing page) A highly stylized pose gives added glamour to a great portrait with an amazing sunset.

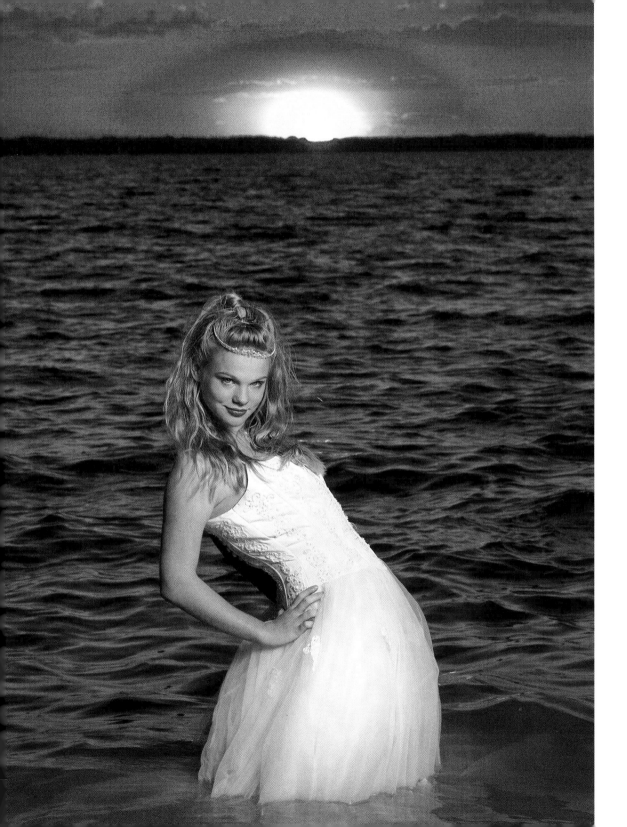

Equipment Used

- Nikon D700

- 105mm f/1.4 lens

- Hensel Porty battery-powered light pack

- Plume Hexoval softbox

- Sekonic L-358 light meter

- Translucent LiteDisc

- PocketWizards

Photoshop Modifications to Final Image

- Used Liquefy to bring in excess fabric at the top of the dress at waist level.

- Dodged the wave surf to bring up the whites in the midtones.

- Erased the distractions in the ocean.

- Made a slight adjustment to the saturation in Olivia's skin tones.

- Adjusted the vibrance and saturation in Olivia's eyes and lips.

- Erased the stray hairs.

"The creative act lasts
but a brief moment,
a lightning instant of
give and take, just long
enough for you to level
the camera and to trap
the fleeting prey in
your little box."
—Henri Cartier-Bresson

4 Soccer Stars

Even though I have children, I'm not a big fan of organized sports. I have always groaned when the signup sheet comes home for a variety of activities that will erode my weekend. I do not have the athletic gene, I barely made it through P.E., and I would never sit through a football game on TV unless it was the Super Bowl—and even then, just so I could watch the commercials! So with all that in mind, you can imagine my eye rolling when I got into a conversation with the father of twin girls who play soccer.

I had been on the lookout for some athletes for a portrait I wanted to do, but 12-year-old girls had not immediately sprung to mind. As with all parents, the man's little darlings were the apples of his eye, and of course they were more athletic and more talented than anyone else. (Do I sound cynical?!) Trying to let him down gently, I revealed that I wanted an action shot, and if it were to be soccer players, I wanted them in midair, flipping or doing a scissor kick or some other highly complicated maneuver, as seen in the World Cup, performed by grown men with names like Maradona or Pele. Without hesitation, he informed me that his girls do that all the time and would be happy to show me at my convenience. Yeah, right—really?

A number of things sprang to my mind immediately, such as, "One or both of them is going to break a leg or worse, and it's freezing outside so the ground is harder than concrete!" Not to be outdone and to see for myself, I picked two possible days for the shoot and forged ahead. If all else failed, I had my eye on a rugby club that would guarantee mud, blood, and guts.

The local forecast was for cold and snow, so with that in mind, I scheduled a Saturday and Sunday and informed the father that I would make the call the Thursday before, depending on the weather forecast. I was hoping for a clear day with blue skies and temperatures in the 40s.

The shot I wanted required the subjects to launch themselves backward from a standing start and then to kick the soccer ball at the apex of the flip with either foot. Technically, this poses a few problems. Players do not take their eyes off the ball, so they would be horizontal to me, and I would get a profile of their faces. Shooting this from any other angle would be unattractive, as you would have the view from between the legs with no head or from behind the head with all feet. So in my estimation, the side-on shot was the way to go.

Professional sports shooters have a little more to work with, as the player is a known commodity—not seeing a player's face does not detract from the brilliance of the maneuver, because everyone recognizes the player's number or reads the accompanying caption to see who he is. I needed a picture that showed my 12-year-old subjects being fabulous and recognizable to their parents.

I build my shots from the ground up, safety first, and then work from that strong base. During the pre-production and planning phrase, knowing it was going to be very cold, I knew I needed to protect the girls from broken bones. I first thought about a gym mat for them to land on, but I decided that it would not give enough cushion on the fall. Remember, this shot was not going to be perfect on the first run through; it was going to require many attempts to get what I needed.

With that in mind, imagine flipping over and over again and landing on your back. Twice would be all I could manage before wimping out. So, I went to the trusty thrift store and bought a twin mattress—the old-fashioned kind with lots of coil springs to give bounce and cushion. It was the best $20 investment for this shoot. I needed to control the action to the best of my ability; the girls would not be doing this as part of a real game, but over and over again directly in front of me. By having a small mattress, not only did I have a safe landing spot for the girls, but I also limited where they would be jumping, spinning, and landing, so I could pre-focus the camera, and the lights would be the same distance from the girls each time.

In contemplating my lighting, I decided to shoot with three SB-800 flash units off camera, controlled by my Nikon D700's built-in commander feature. This is a great feature that is not standard on Nikon's more expensive cameras, and if you have the D700, you should utilize it. It allows you to control wirelessly the flash's output individually from the camera, and it gives you a very portable lighting system. The main reason that the built-in commander feature exists on the D700 and not the D3 is because the D700 has a built-in pop-up flash, and that flash can be used to control the remote strobe(s) you are using.

NOFEAR

Test your system before walking out the door. Don't try to use the commander system for the first time on shoot day.

"I build my shots from the ground up, safety first, and then work from that strong base."

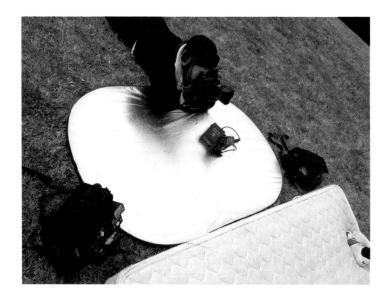

A simple setup with three strobes controlled wirelessly in commander mode.

I also included a silver reflector beneath me to add some fill underneath them and, as a backup, a softbox with 300 feet of extension cable. I wanted to shoot with a very wide-angle lens, a fisheye, that would allow me to get inches away from my subject. By keeping the subject in the center of the lens, you maximize your image space and minimize distortion on the edges, and the resulting portrait sucks you into the action.

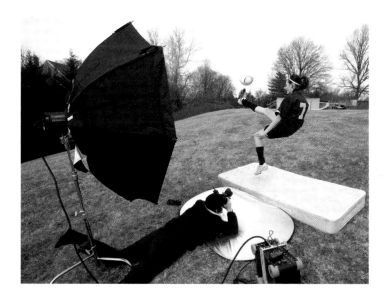

Prepared for anything, with extra equipment, but ultimately shooting available light.

"By keeping the subject in the center of the lens, you maximize your image space, and the resulting portrait sucks you into the action."

The site I chose for the shoot was directly across the road from the girls' house—a small park on a hill. I had previously scouted the location and had ascertained that if I shot on the slope of the hill, it would give me the best chance at nothing but sky behind the girls. Knowing I would be lying on the ground to get the shot gave me precious inches I needed to give the portrait the weightless feel I wanted.

The weekend of the shoot rolled around, and it was miserable. The ambient temperature was 19 degrees and overcast with the possibility of snow. The father confirmed that the girls were gung ho and pumped to proceed, so I pulled on my snow pants and grumbled my way out the door. The fact that the sky was blah and a shade of *nothing* did not put me in a good mood, but I decided that I could use tungsten gel on the flashes to turn the sky blue and hope that the girls were in a better mood than I was. Did I say it was cold? It was beyond cold, and my fingers were so frozen around the camera that if I put the camera down, my fingers didn't move. I did all my test shoots before bringing out the talent, as I did not want to kill the momenentum once they realized how cold it was.

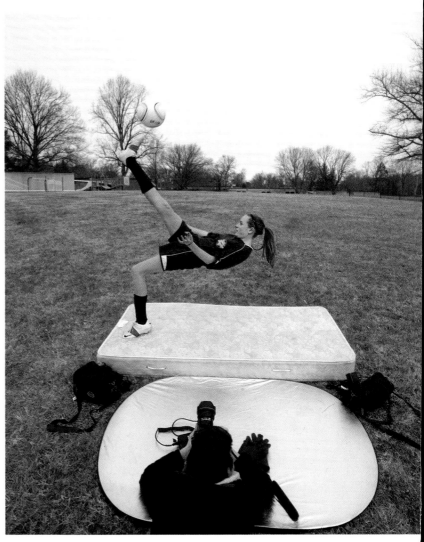

Shooting low guarantees the illusion of extra height, even though my subject is only three feet off the ground.

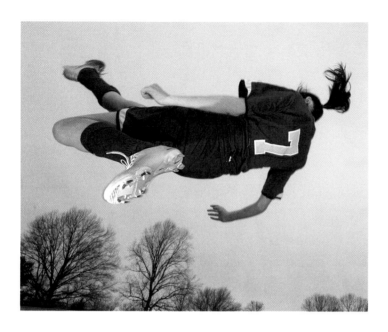

This image shows the effect of tungsten gel on your strobes. If the subject was world-famous, #7 would be all I'd need. As it was, I needed a face.

Dad came first, with a bag of soccer balls and a ton of enthusiasm, telling me the girls were wrapped in robes to keep warm and had just finished their makeup. Was anyone else ready to call it a day? Check, please. I'm lying on my stomach, it's cold, and they were in robes and makeup.

This is where I learned a little something about the spirit of soccer and the girls who play it. Dressed in shorts and T-shirts, these girls were dynamos of determination and competition. After listening to a short speech about safety and me telling them it was okay to fall on the photographer, they literally threw themselves into the spirit of the portrait—flipping over and over again, one girl stopping only when she was winded and tagging her sister to continue.

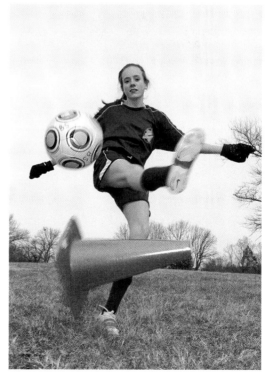

Warming up and fearlessly aiming at the photographer.

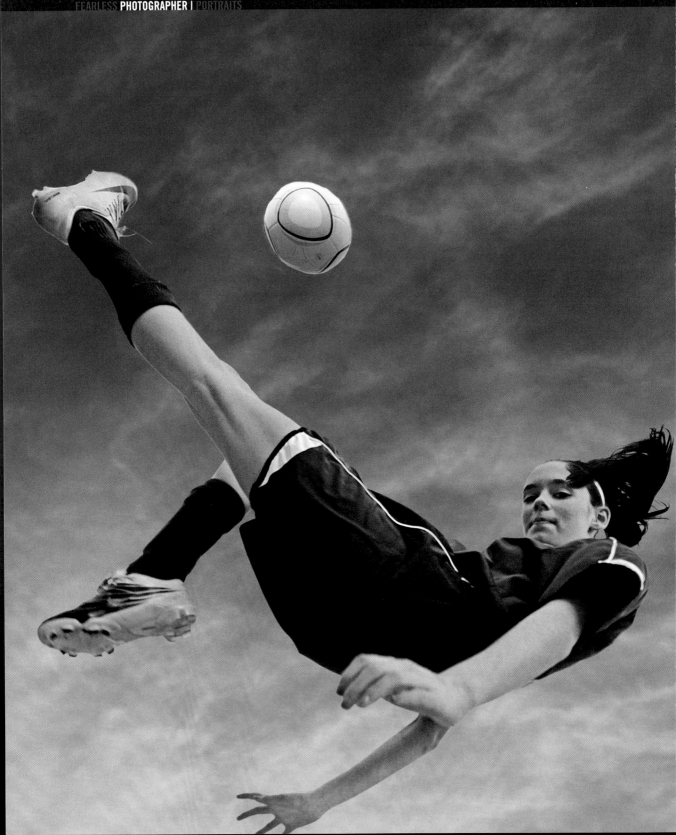

I was blown away by the talent of these girls—true to their father's word, they could jump backwards and kick a ball with either leg! Now the problem was me keeping up with them. It became apparent fairly quickly that the recycle time of the strobes was not enough to nail the shot, because I could only get one flash per flip. I needed to shoot continuously throughout the entire flip to ensure the exact moment of impact and to keep the ball in the shot. Sure, I could add the ball in later in Photoshop, but I owed it to these girls to show the real deal—they were delivering, and I needed to rise to their level.

Sports photographers have that built-in sense from shooting hundreds of thousands of images. They know what their shutter lag is and to anticipate peak action at the exact right moment, but they, too, shoot fast and furious. That's when I shut down the flashes, amped up my ISO to 1200, changed my shutter speed to 1/1000, and shot with available light. With a shutter speed of 1/1000, I was also better able to freeze the action.

The same rules apply in this type of shot as in any portrait that requires physical effort—when the subject gets tired, the shots do too. These girls were amazing and definitely brought everything they had to bear—and it shows in the final pictures. But when it's cold, it's cold, and when they flipped their final flip, I knew it before they did. The competitive spirit that drives them was very obvious, and they would have kept going, but I knew they would be aching the next day. When I called the last shot, they ran home for hot chocolate and central heating, and I packed up for post-production, my fingers numb.

NOFEAR

Angle is everything. The lower you get in an action shot, the more dynamic the portrait will be. Shooting low gives the appearance of feet, not inches, off the ground.

(Facing page) Proving she's "all that," Ms. Kelly not only nails the ball, but also stares me down.

From every shoot, you learn how you would do things differently the next time around, and this shoot was no different. But apart from the sky, I was fairly confident that I had something I could work with, considering the Arctic conditions I was forced to deal with.

Then it happened. Halfway home, the overcast, lifeless sky turned to the most gorgeous shade of azure blue, and I stopped the car and cursed. By now you know that I try not to overuse Photoshop, but this was one of those moments when I decided that my subjects deserved this background. I was not shooting photojournalism, but a portrait. My background sucked, and this was the one we should've had, but I was not about to ask those girls to redo the shoot. So I shot the sky. Yes, they got a fabulous blue sky one hour after the shoot ended, but it doesn't change the fact that they can kick a ball upside down with either leg while looking at the camera!

"*If you never did you should. These things are fun and fun is good.*"
—*Dr. Seuss*

(Facing page) Perfect technique. Notice how the ball changes shape due to the force of the kick.

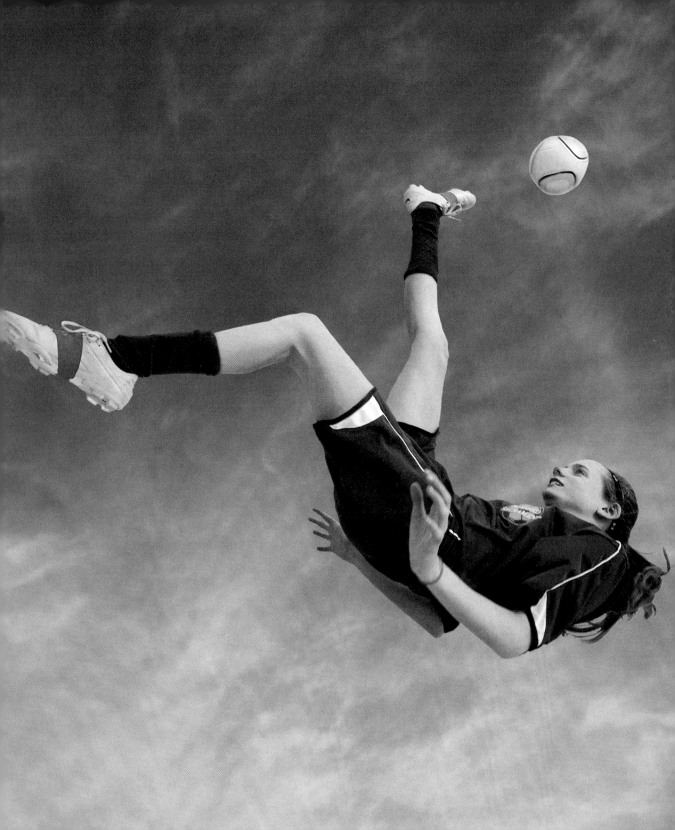

Equipment Used

- Nikon D700

- Nikon 14mm-24mm f/2.8 lens

- Three SB-800 flashes

- Silver reflector

- Twin mattress

Photoshop Modifications to Final Image

- Dropped out the overcast sky using Color Range.

- Replaced the sky using Layers.

Part II

Teenagers: Give Them Their Props

The teenage years are difficult, as you are straddling two worlds. You want desperately to be taken seriously, but you can't do anything without your parents' permission or money. More often than not, we find teenagers being depicted in surreal poses, leaning against columns or trees in fluffy sweaters and very blue jeans with loads of hair-light and a soft focus. Ha! Do you really think that is how the average teen sees herself?

Teenagers are longing to fly, shed the chains of home life, and be free. I think that is a great place to jump from and make extraordinary pictures. Depending on your subject's age, you need to set clear goals with the parents and make sure everyone's on the same page. Thirteen is very different from nineteen in terms of what can be done artistically. I am going to show you two of my favorites that put a girl and a guy right where they want to be depicted pictorially, and I'll show you how, with just a little effort, you can make a great portrait.

"*Photography suits the temper of this age—of active bodies and minds. It is a perfect medium for one whose mind is teeming with ideas, imagery, for a prolific worker who would be slowed down by painting or sculpting, for one who sees quickly and acts decisively, accurately.*"
—Edward Weston

5 Hunter:
Rock Star

I am influenced by things I see every day, and one example is the enormous flags that fly over car dealerships. These flags are monstrous, and I'm drawn to them like a moth to a flame. Don't pretend you don't feel the same way!

I decided to use one as a backdrop in another idea I had for a rock-star fantasy image. First, you need to get a flag, and the rest is easy!

Don't go crazy and get a huge flag, as you will need a place to hang it, and extremely large flags are also quite heavy. I happened to have a 30×16-foot flag that was just right for the space I needed to fill. I hung it from three heavily sandbagged backdrop stands and loosely clipped it to the poles. I wanted the flag to have the feeling of flying in the wind and not be just a static backdrop, so I had two assistants (groupies) shaking the flag from either side to give it some motion.

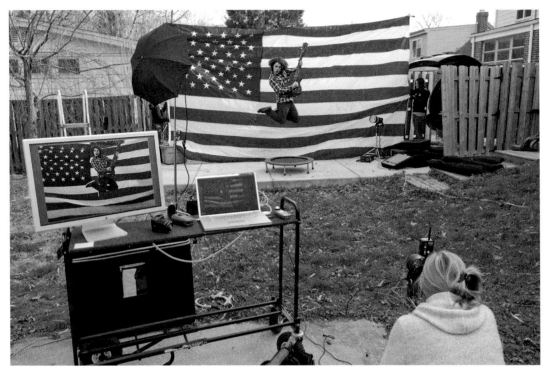

(Above) My overall setup that utilizes the space to its best advantage. (Below) The high view of the location. Any backyard can become your playground.

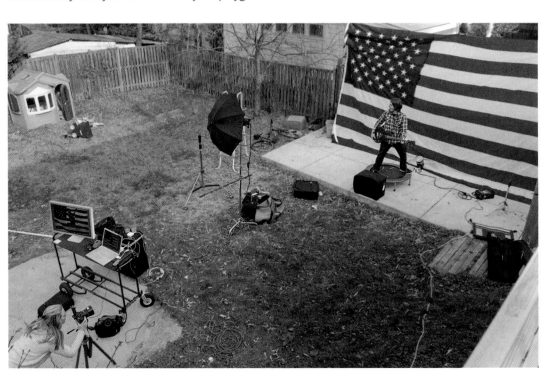

Now all I needed was a crazy guy with a guitar and no inhibitions. It turns out that there is no shortage of men who play air guitar, Guitar Hero, or the real thing. Everyone's a budding star….

I needed a physically fit individual who could bounce on a trampoline and play and look the part, so I recruited Hunter. Anyone who has ever bounced on a trampoline knows that after two minutes, it is no longer fun. It's hard work, which is why it is used in many gyms as a form of exercise. I needed Hunter to bounce, pose, play, and look alive, not exhausted.

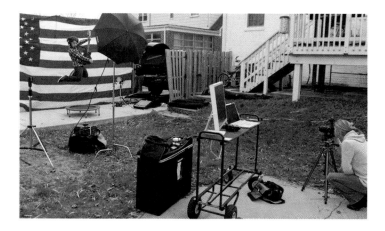

I shot low to add height to the shot and to allow for the bounce from the trampoline.

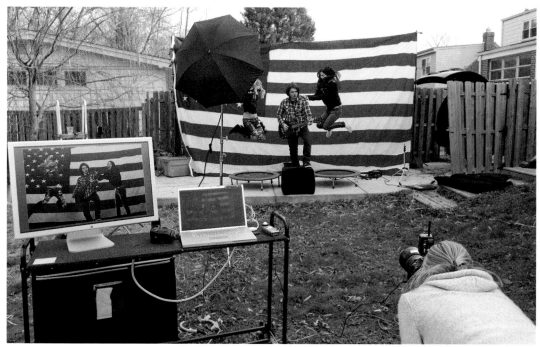

Keep the shoot fun and let the subject let off some steam between the main shots.

NOFEAR

Get your subject used to the trampoline before introducing props, such as a guitar (especially if it's expensive).

The lighting for this shoot was quite simple, which I prefer, but it was a little dramatic to give the feeling of being on stage. I had a reflective umbrella as the main light and a strobe with a reflector as a backlight, as well as the benefit of available light from an overcast day as a fill.

The beauty of digital is that you can change your lights with ease. Never settle if the light is not what you thought it would be—move something. My first lighting setup had my backlight too far to the right of Hunter, and it was not adding anything in the way of an edge. So I moved it directly behind him and used one of my light cases as a gobo, as I saw a little flare. I wanted just enough light to give a glow to Hunter's legs, as if he was lit by a funky stage light.

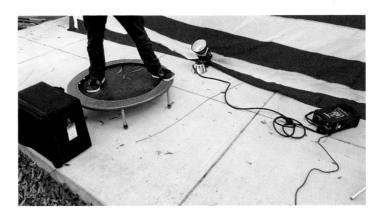

The backlight is very simple; notice the black case in front of the trampoline acting as a gobo.

"Never settle if the light is not what you thought it would be—move something."

I lit the flag with plain old-fashioned available light, and I set the main light to one stop over that. It was a perfectly overcast day, so I didn't need to worry about shadows.

You need a fast shutter speed to freeze the action, so I was at 1/250. Because I had restrictions with my framing, I used a tripod to make sure I nailed the shot on the head. When you know the framing of the shot, a tripod makes it so much easier. I needed to shoot Hunter right in the middle of the flag, and hand-holding the camera would have been too loose.

My hat is off to sports photographers who constantly are chasing moving subjects, constantly trying to frame subjects and simultaneously capture peak action. Remember that even with the best lighting equipment, you will only get one shot per bounce on the trampoline (because your lights have to recycle), so framing is critical.

NOFEAR

Use a small f-stop to give you the most depth of field, as your subject will move back and forth on the trampoline.

I love to shoot outside. It's so freeing, and you get to make noise and a mess without much concern. I set up this shot on a backyard parking slab. I shot this tethered, as I needed to be free to demonstrate to Hunter all that goes into a great action shot. Perfect leg placement, perfect expression—it's so much easier to show the subject what they are doing than to tell them, because they get it instantly when they see it.

"I wish more people felt that photography was an adventure the same as life itself and felt that their individual feelings were worth expressing. To me, that makes photography more exciting."
—Harry Callahan

After two or three tests where Hunter could see the results of his hard work, we fine-tuned it to the point that it was hard to choose the final image. I ended up with three that I loved but only one that had all the elements. I wanted the flag to look alive and Hunter to be really animated and connecting with me, as if I were the audience at his concert.

NOFEAR

Know when to quit. When the subject gets tired, the shots do, too.

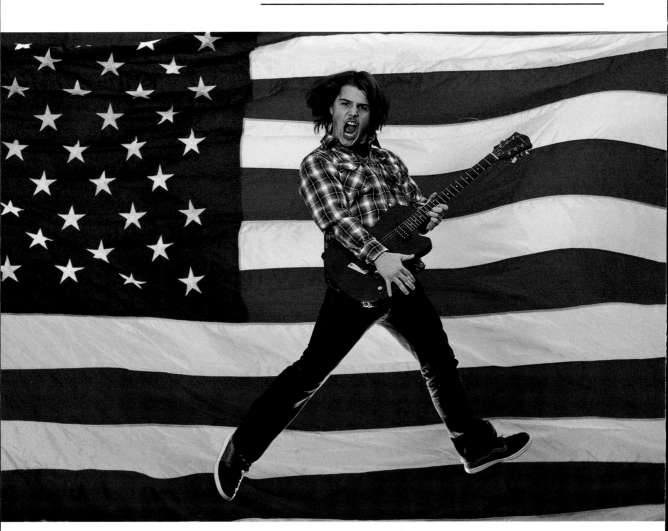

Another great shot. It's hard to have a favorite when the subject is so talented.

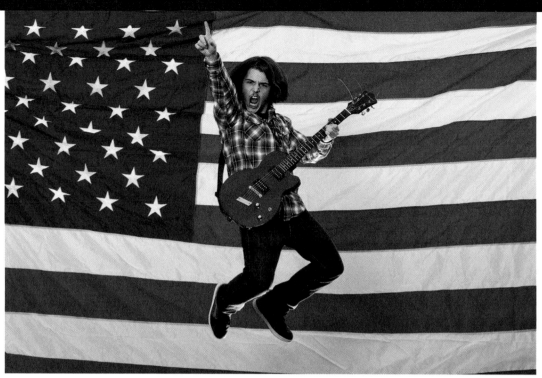

A solid rock star–themed portrait that any red-blooded man would love.

This one was shot just for fun, but if Hunter breaks into the big time, it's coming out of the archives!

This is the picture I wanted—plenty of movement in the subject and flag with great eye contact.

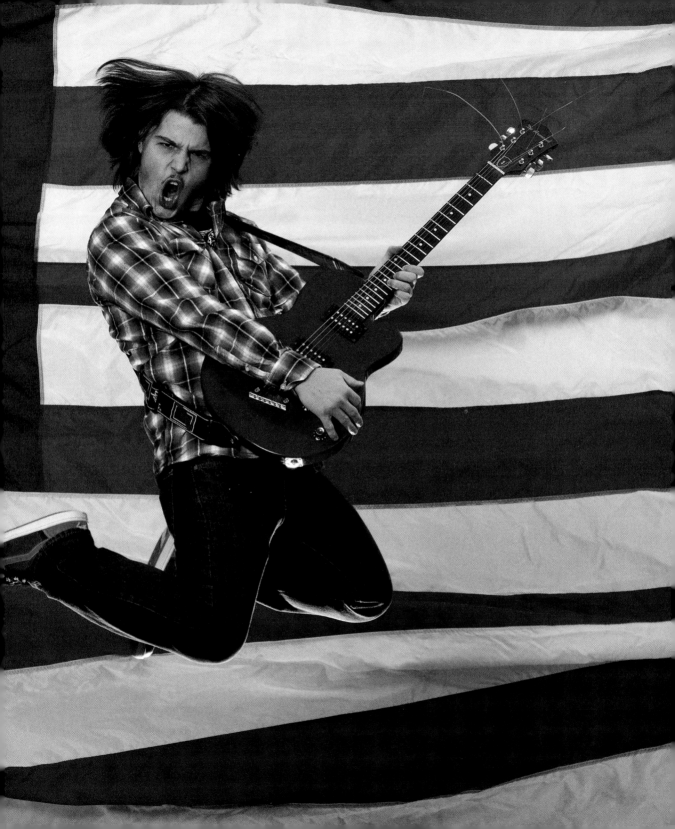

Equipment Used

- Canon EOS-1Ds Mark III

- Canon 85mm f/1.2

- Hensel Tria 1500 and Hensel 3000 head

- Umbrella with white reflective insert

- Exercise trampoline

Photoshop Modifications to Final Image

- Cloned out errant crease in flag.

"As I have practiced it, photography produces pleasure by simplicity. I see something special and show it to the camera. A picture is produced. The moment is held until someone sees it. Then it is theirs."
—Sam Abell

6 Madeline: The Definition of Glamour

This generation has many influences, from music to movies and even books. Madeline has a few items that her great-grandmother left to her, and I thought it would be great to put together a simple but powerful portrait using some costume jewelry, a fur head wrap, and a coat.

I wanted a very tight shot of her face and decided to use a beauty dish and a very shallow depth of field. Getting the 1.4 f-stop I wanted meant that the light source had to be controllable to a very low level. The best piece of equipment for this is your trusty flash. I used my SB-800 set at 1/32 power inside the beauty dish. With studio strobes, there would have been no way I could've reduced the light to f/1.4, even when I was at ISO 100, except for using a lot of neutral-density gels. However, I wanted a large yet directional light source, and the beauty dish was a great solution for that. This allowed me to get very close to Madeline without overexposing the portrait.

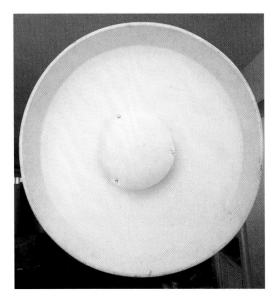

The beauty dish. Note that the light source in the center is forced out to the sides.

The beauty dish is directly over the top of the camera to reduce shadows on one side or the other for an even light.

A very simple setup utilizing one strobe unit tucked into the center of the beauty dish.

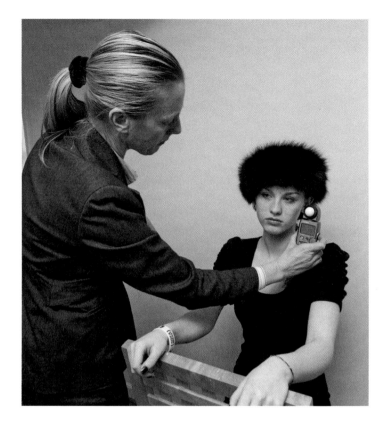

Using a meter gets you to a great starting point and removes the guesswork— buy one.

I wanted to use this shallow depth of field for a number of reasons. First, Madeline has amazing eyes, and I wanted to focus in on them. Also, being a teenager, Madeline does not have perfect skin, and a shallow depth of field helps out with that.

This setup does not take up a lot of room, so just find a non-descript background, such as a plain wall. In this case, it was shot in her dining room. We wanted to re-create some of the great movie-star looks of the '40s with dramatic but simple beauty, light, and glamorous accessories.

"I always feel that less is more when it comes to makeup."

I always feel that less is more when it comes to makeup, unless it is a high-fashion shoot—but even then I am more about the natural beauty of teenagers. Madeline is wearing lip gloss, face powder, a hint of eye shadow, with a touch of eyeliner and mascara. I didn't want anything too heavy, as the props she was wearing and the depth of field would be enough to make this portrait sing.

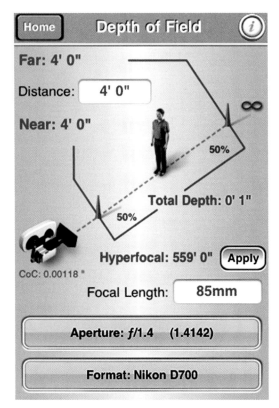

For all you tech junkies, this is a screen grab of the pCAM app that I used to determine a one-inch depth of field.

When using a shallow depth of field, focus is critical. At f/1.4, there is only an inch of play, and then you are out of focus. There are some interesting apps you can get if you are a tech junkie—one such app is pCAM, a film and digital calculator. This allows you to know instantly how much depth of field you will get from any lens/camera combination. At f/1.4, it is not a lot!

Your subject needs to be comfortable and hold still to maintain your focus. I opted to use a tripod to make sure that I was doing my part, and Madeline did her best not to wiggle. I had her sit in a chair; because I was only shooting her face, it made sense to have her seated and still.

Working with a shallow depth of field is a lot of fun creatively, but you need to understand how the plane of focus works. I have shown you two examples with me changing the focus from one eye to the other. Notice how other objects in the portrait come into and out of focus as well. When I focus on her right eye, the earring closest to us comes into focus also. That is because it is on the same plane as the eye. This can provide a challenge if you do not want to accentuate certain features, but it is a much-underused style of portraiture.

I decided that she needed more over her shoulders, so I added the coat. I wanted the fur to completely cover her hair to give that luxurious Russian-spy feel to the portrait. Even though we were going for the smoldering movie star, we did a few laughing shots, and those were my favorites. I changed my aperture to give me a more generous depth of field, and I think you can see how a simple change like that can alter everything.

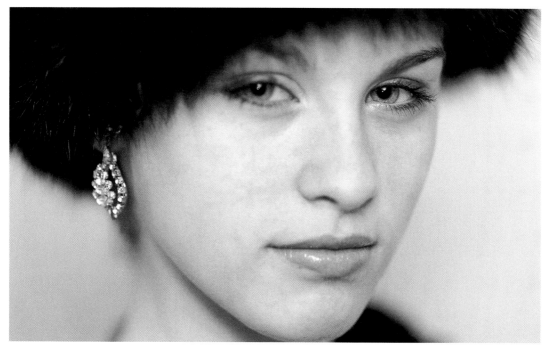

Notice in this image that both the earring and the subject's left eye are the only things in focus because they are on the same plane, despite there being only one inch of depth of field.

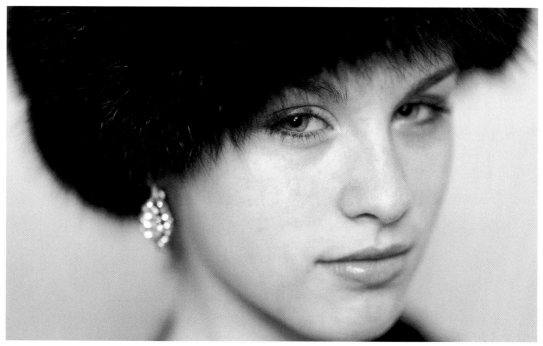

Changing the focus point to the subject's right eye drops the left side of the subject's face out of focus.

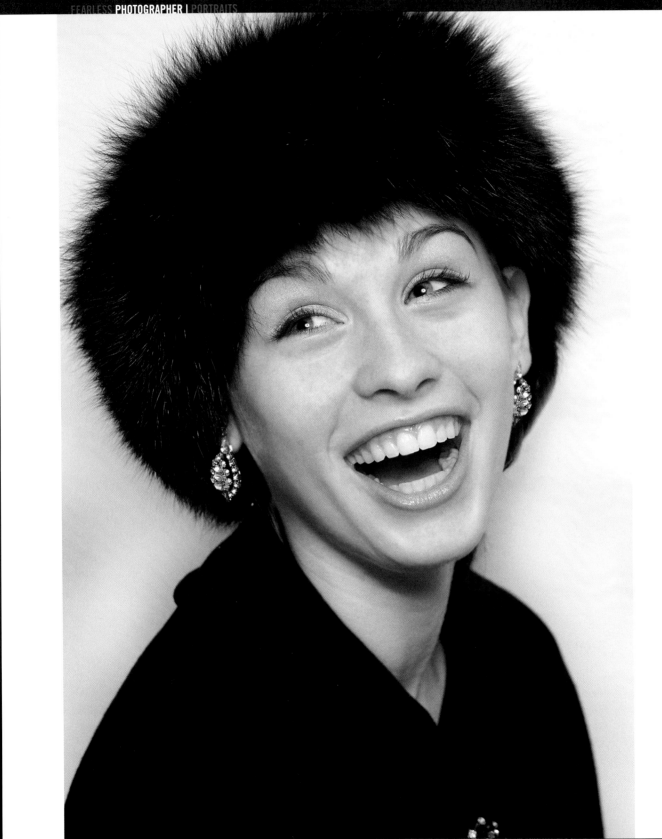

Because our subject is young and beautiful, I decided in post-production that I would change some of the images to black and white and leave the eyes in full color. This technique added another layer of intensity to the shallow depth of field and, of course, just makes those amazing eyes pop.

The black-and-white filters do more than just desaturate the color; they also clean up the texture and look of the skin. Although Madeline has great skin, she is very pale, and any red shows up as blotches that draw the eye toward them. Using three different black-and-white applications in the Alien Skin software, I was able to create three very different-looking portraits from the one shoot. The full-color portrait of her was exactly what she is—a beautiful young lady having fun. Even though it would have looked great as a black and white, I think it captures the true essence of her the way it was shot.

NOFEAR

Don't assume that your client wants you to take something out in post-production. Discuss with your clients whether they want any retouching done *before* you do it!

> "*P*hotography deals exquisitely with appearances, but nothing is what it appears to be."
> —Duane Michals

(Facing page) Using f/8 changes everything, and now we get to see natural beauty all in focus. (Page 74) Finishing this image with Alien Skin's Exposure 3 Kodak Technical Pan – Technidol Low Contrast preset. (Page 75) Finishing this image with Alien Skin's Exposure 3 High Key – Glowing Skin from the effects preset. This image has the look and feel of a portrait her grandmother may have had.

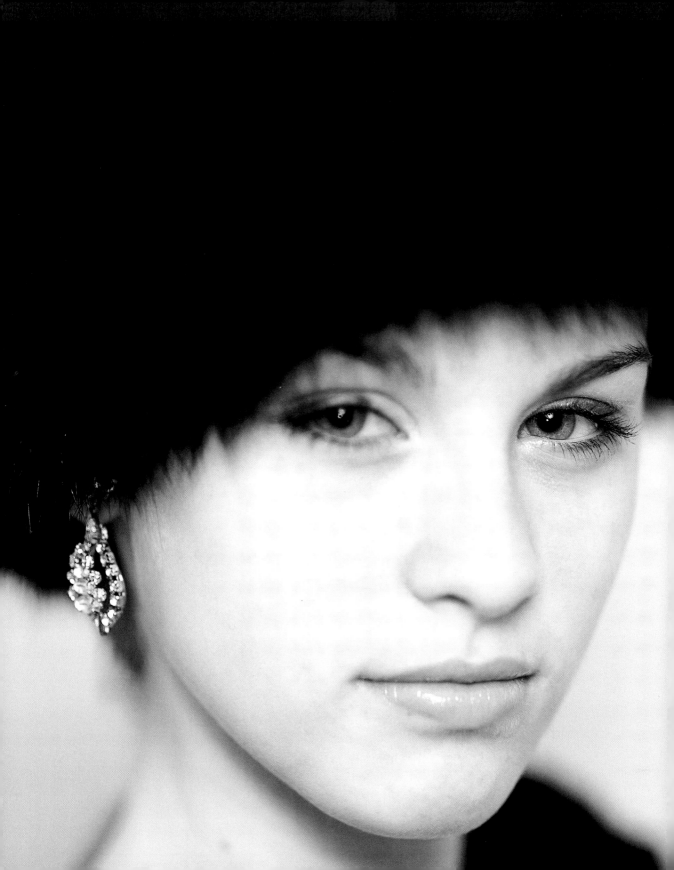

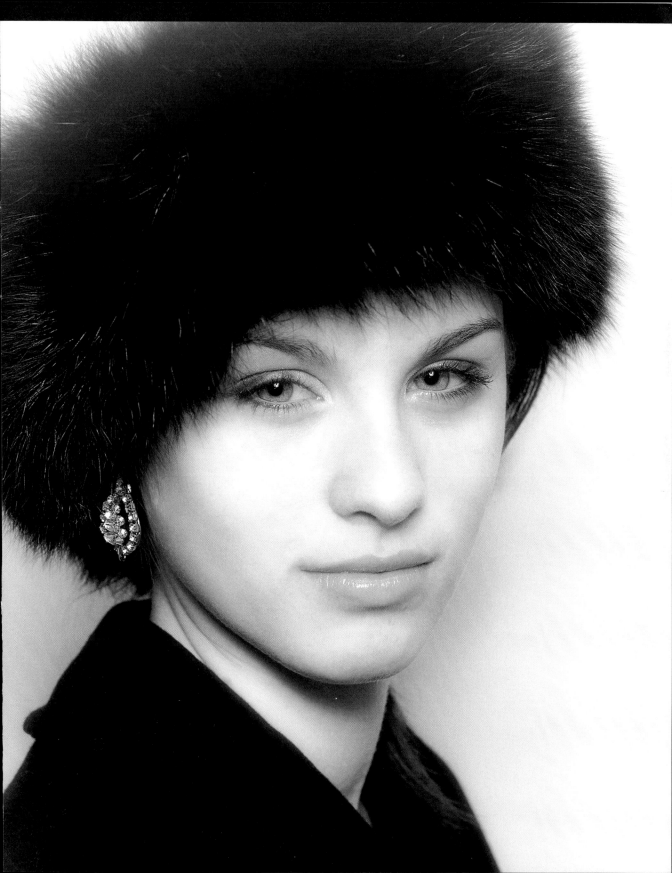

"There are always two people in every picture: the photographer and the viewer."
—Ansel Adams

Don't assume that your client wants you to take something out in post-production. You don't want to remove a mole only to find out that it's a family trademark. In this digital age, people are all over using the incredible tools at our disposal, and many times the finished portrait looks nothing like the subject. Take the time to discuss with your clients how much (if any) retouching they want you to do. If you overdo it, you run the risk of making the client feel as if she *needs* all that work done to look decent, and that is not the case. Natural beauty is far more appealing to me. In the case of Madeline, her grandparents need to recognize her in the portrait and not look puzzled when they're handed a portrait of someone they don't know.

I do think it is a given that festering boils should always be removed, but that's just me....

(Facing page) Finishing this image with Alien Skin's Exposure 3 Kodak Technical Pan preset.

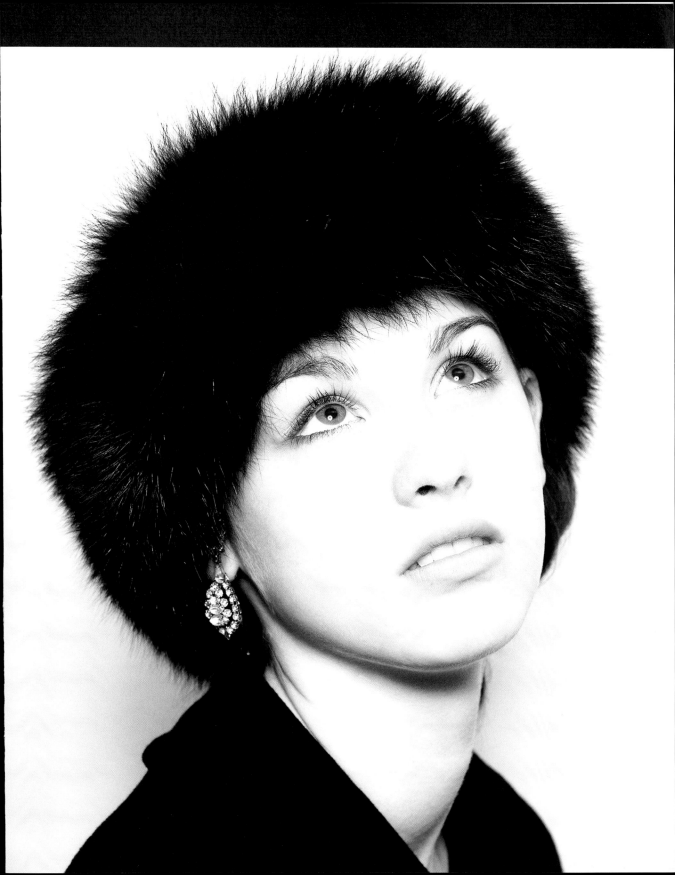

Equipment Used

- Nikon D700

- 85mm f/1.4 lens

- 21-inch beauty dish

- SB-800 strobe

- Sekonic L-358 light meter

Photoshop Modifications to Final Image

- Removed skin blemishes using the Patch tool.

- Converted to black and white and adjusted using Alien Skin.

- Used the Gaussian Blur filter on the full-color portrait.

Part III

Compassionate Portraiture

There are portraits that are difficult to shoot for a number of reasons. Perhaps the subject is awe-inspiring, humbling, or larger than life, and you feel in the pit of your stomach that it is a one-shot deal; the stress level is sky high. These pictures will shape you not only as a photographer, but also as a human being. They leave you with something. You grow as a person and leave affected—hopefully in a good way. Let's look at few that were important to me, and maybe you'll be inspired to go after a few of your own.

"The fishermen know that the sea is dangerous and the storm terrible, but they have never found these dangers sufficient reason for remaining ashore."
—Vincent van Gogh

7
Blaine:
A Man with
a Message

Would you know the difference between genius and insane if you saw it? Blaine will make you rethink everything you thought you knew about the human race. He is on a mission—a quest to change America one elderly, infirm person at a time. Blaine believes that we all should live to be 120 years old and that the only reason we are not is because we're not taking care of our bodies. He believes we need to walk more, and he has created a system called weight walk. It involves carrying weight over your shoulder as you walk. Great, right?

Blaine lives outside, in all weather and all seasons. He has a megaphone, a homemade billboard, and a website. He invents things constantly, such as a laptop holder, a hands-free umbrella, a garment bag, belt hooks, and many other space- and time-saving gadgets. He keeps his shoes together with duct tape and recycles everything.

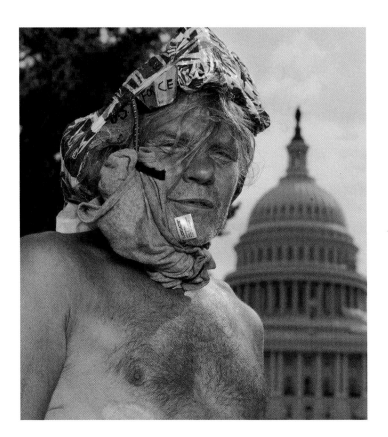

One of the many inventions Blaine has worn with pride.

From the moment I met Blaine, I knew I wanted to photograph him. He is an incredible resource on many different topics, and we've had conversations on everything from politics to healthcare, technology, and dating.

I wanted to photograph Blaine doing what he does every day, in the location he enjoys the most—the U.S. Capitol grounds. Blaine was happy and willing to be photographed, as he needed some good pictures for his website. I formed a plan to shoot him with one small handheld softbox that would move quickly, as Blaine doesn't sit still for very long. I wanted to treat him as the entrepreneur he believes he is, so I used my 85mm portrait lens to give him a rich quality in the finished picture.

(Facing page) Demonstrating his product, the weight-walk system.

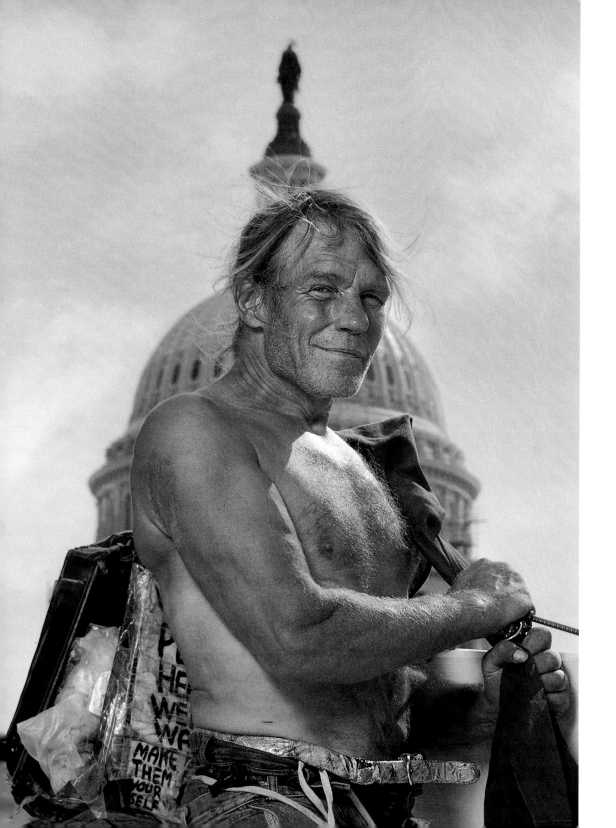

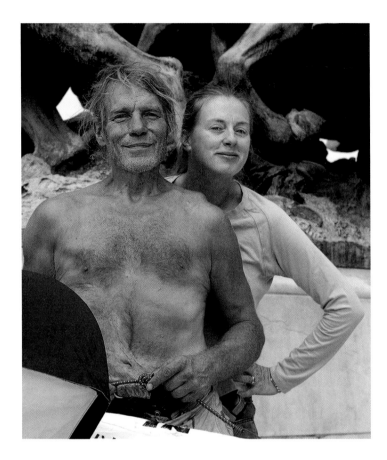

Myself and Blaine.

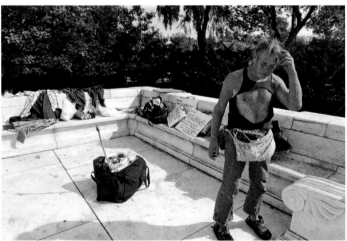

(Above) Blaine and his belongings. (Facing page) A fascinating portrait that shows the weathered features gained from outdoor life.

Blaine was busy cleaning up his space when I arrived. He was very keen to get started and wanted to know all about my strobe and whether there was a laser in the softbox! That set the tone for the shoot; I let him be himself and tried to keep up as he roamed around, demonstrating his invention. It is key to let people be themselves when you're shooting for realism. Blaine is a larger than life character, and I did not want to take away from that in any way.

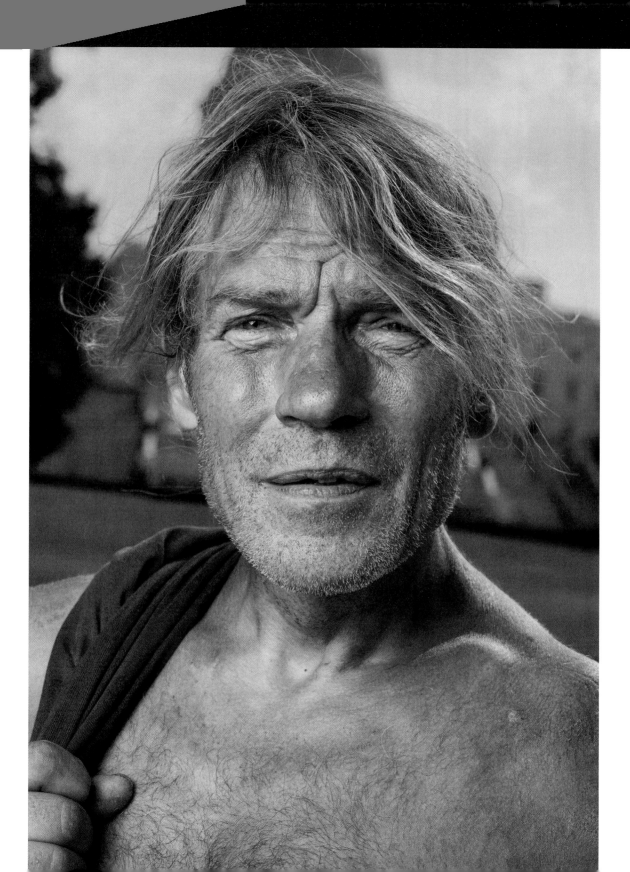

One interesting thing about shooting outside in a public location is the lack of respect that accompanies the job. Even though I was lying on the ground in a vulnerable position, the tourists acted as though Blaine and I weren't there, something I suspect many people who choose a different lifestyle are used to.

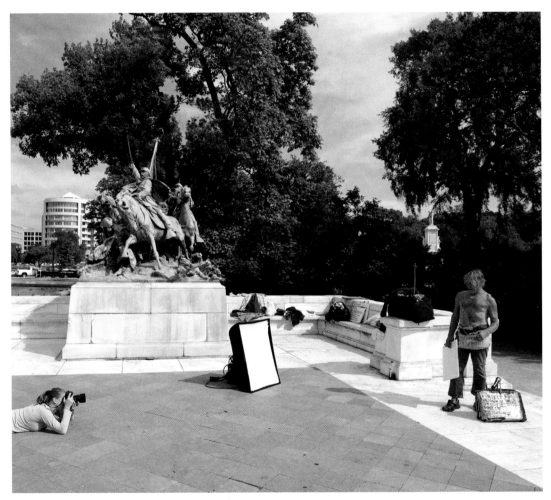

Never too proud to get down low for the picture.

"It is key to let people be themselves when you're shooting for realism."

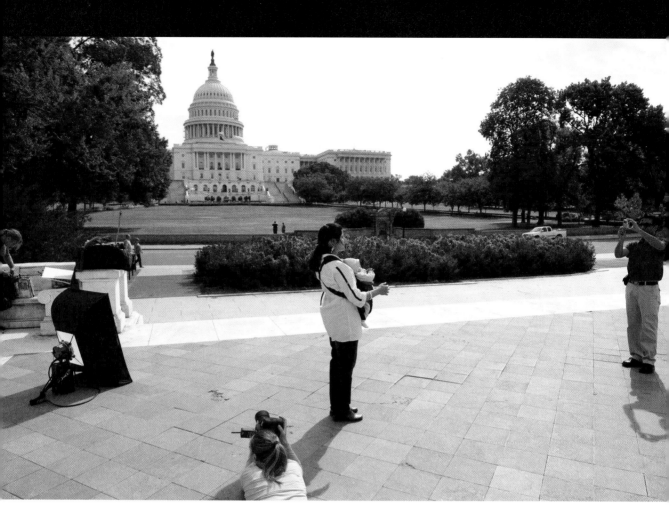

Tourists oblivious to my proximity.

I wanted to get a full-length portrait of Blaine with the Capitol as the backdrop, to anchor him to the location and to show the disconnect of his chosen life against the shadow of the seat of our nation's power. I also wanted a close-up showing the pure, unfettered expression of his will and determination.

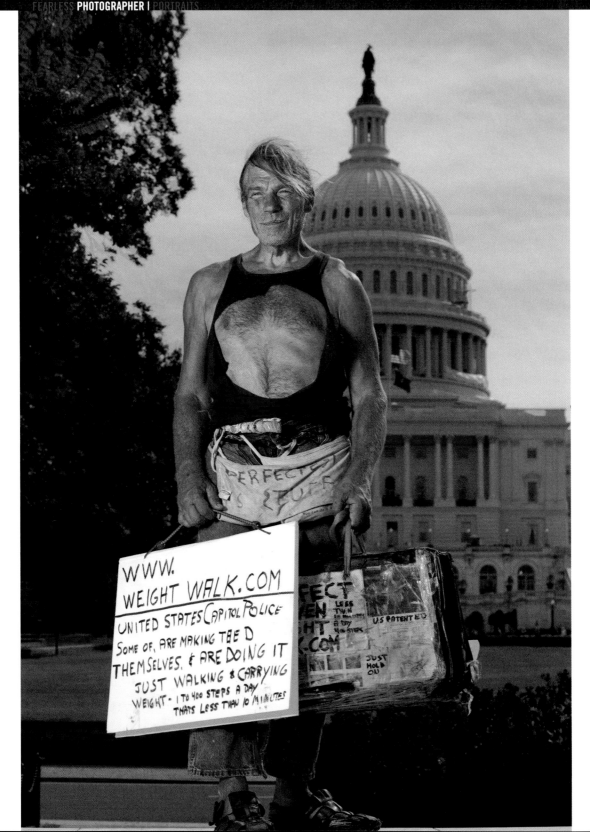

I ended up with a good mix, especially given that he was not stationary for very long, which required me to shoot around his meanderings at the site, and that he took very little direction from me.

On a shoot like this, it is critical to have an assistant who understands lighting. When you are moving, the light needs to move with you to maintain your exposure, and the relationship with your assistant becomes indispensable. When you are focusing on your subject, you don't want to have to worry that your light just moved six feet away and your perfect shot is underexposed, because the light-to-subject distance changed. I chose a single softbox with portable battery power because I didn't have any power outlets nearby, and we needed to be flexible with the mobility of the lights.

NO FEAR

Don't be afraid to get down and dirty. I end up lying on the ground a lot. Try different angles and perspectives. If you are running out of ideas, shoot low, from the side, or even behind your subject.

"*There is one thing the photograph must contain, the humanity of the moment. This kind of photography is realism. But realism is not enough—there has to be vision, and the two together can make a good photograph.*"
—*Robert Frank*

(Facing page) The man on his mission as I see him most days of the week.

Equipment Used

- Nikon D700

- 85mm f/1.4G lens

- Hensel Porty battery-powered light pack

- Plume 100 softbox

- PocketWizards

- Sekonic L-358 light meter

Photoshop Modifications to Final Image

- Added blue to sky.

- Added clouds using the Cloud brush.

"*While there is perhaps a province in which the photograph can tell us nothing more than what we see with our own eyes, there is another in which it proves to us how little our eyes permit us to see.*"
—Dorothea Lange

8 Talley:
Renaissance Mother

When it comes to pictures painted by the old masters, even non–art lovers are blown away by the attention to detail and the use of light and texture. I have always been drawn to Renaissance-era paintings depicting women draped in satin and silk, reclining on chaise lounges or floating in the heavens. As vulnerable as these poses are, the women always look serene and calm, very much in control of their state. In their gaze or smile, you can see a hint of what lies beneath. I wanted to re-create this theme in a portrait, and I found the perfect subject in Talley.

Talley was pregnant—a glorious state to find oneself in! It's a time of adventure, hormones, weight gain, and cravings! This was Talley's second child. Her first is a wonderful little girl who fills her days with tea parties and love and who was born with spina bifida. Talley never wavered in her choice to have her daughter, and when she decided to have another child, she did so knowing that the chance she would conceive another child with spina bifida was extremely slim. Eager to expand her family, she became pregnant—and at three months along, Talley was told she was carrying another child with spina bifida.

Those of us who have children with run-of-the-mill issues such as "big personalities" have no idea of the dedication involved in caring for a child with serious medical issues. Mothers carrying children with medical problems have a narrow window of time to decide whether they want to continue the pregnancy or terminate it. I, for one, cannot begin to imagine the stress and soul-searching one must go through to make that kind of life-changing decision. Talley, with the unwavering support of her husband, decided to forge ahead and make plans to bring another wonderful child into the world.

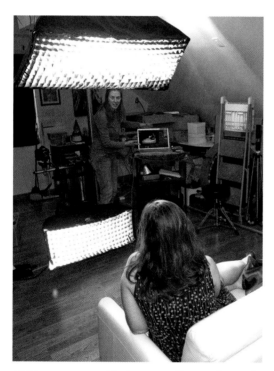

Making sure my subject can see the monitor and is comfortable before we begin.

I wanted to shoot Talley in a way that would show her as confident yet feminine, and as fragile, graceful, and at peace. I had two setups in mind, and with the old masters in my head, I laid out a plan to remake the old with a modern twist.

NOFEAR

Don't be afraid to ask friends to pose nude, semi-nude, or seemingly nude with strategically placed items.

My first portrait required blue and purple satin, a leather couch, and a naked Talley. I love to shoot nudes, but the key is always the person. If your subject is not fully invested, the resulting portrait will be strained. Talley and I had discussed beforehand the look and feel of the picture I was trying to create, so she had time to ponder and digest the idea before the big day.

I wanted a very clean, modern edge to the portrait, with no competing props. A thunder-gray seamless backdrop and a wooden floor allowed Talley to dominate the picture. Unlike many of the great masterpieces of the Renaissance age, which featured cherubs and angels, plants, and heavy brocade, I wanted to keep the fabric element and strip away everything else. I chose to shoot with lights that would accentuate the luxurious folds in the satin and would give me beautiful shadow detail.

The lighting setup was simple—two strip-light softboxes with the Lighttools egg-crate grids on either side for a wide but short light that was soft as well.

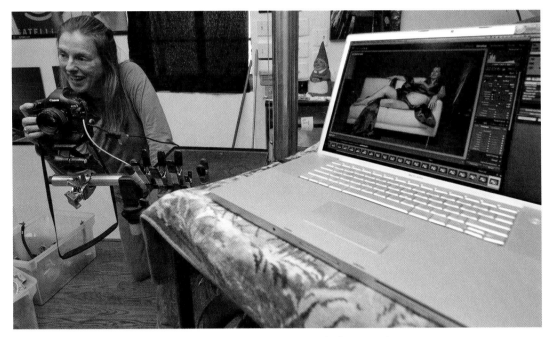

Shooting tethered is wonderful when you want instant approval of your work.

I shot this portrait tethered, feeding directly into the computer for instant review and discussion, because I wanted Talley to see every frame I made so she would feel comfortable with the whole process and the final image. Also, I wanted to micro-adjust her poses to get just the right look. If you take the time to analyze the old masters' works, you will notice that the hands play an important role. Fingers are always alive and posed perfectly. These little elements make the final piece.

Pregnancy brings with it many discomforts, so be aware that any pose that needs to be held for a while may be uncomfortable and difficult for the mother-to-be. If you try to re-create the actual poses in many of the original works, you will notice that it is quite painful! Most of the women are bent at the waist in an L shape while reclining; give it a whirl and then feel sorry for all the models of yesteryear!

Most of the nude art we see features a naked model covered only with a well-placed swath of fabric. I shot a few of the couch series with one of Talley's breasts exposed, but it did not add anything to the picture, so the final image I chose has her pretty well covered.

NO FEAR

Be professional and don't act shocked if body parts meant to be a suggestion become front and center. It happens.

*"I love to shoot nudes, but the
key is always the person."*

*My pick, a modern twist on an age-old theme
with our subject looking confident and at peace.*

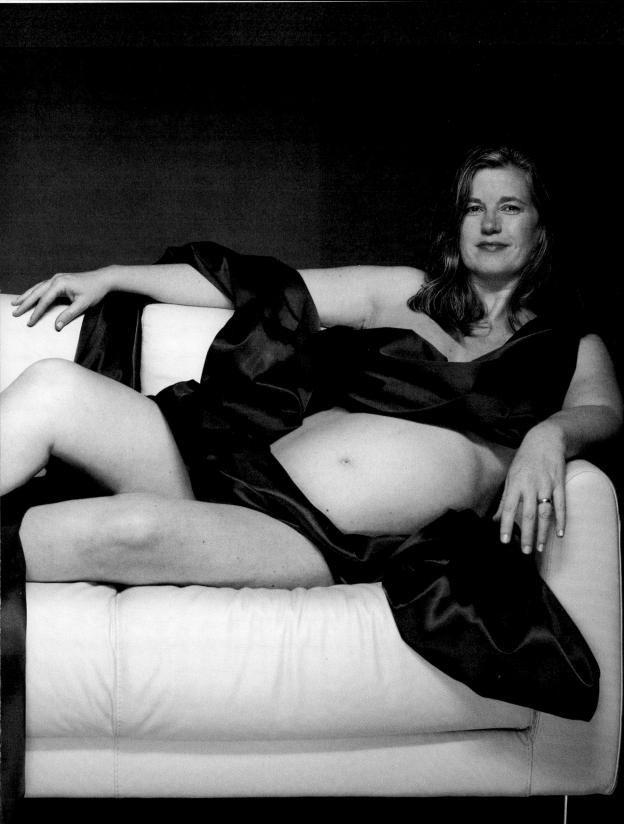

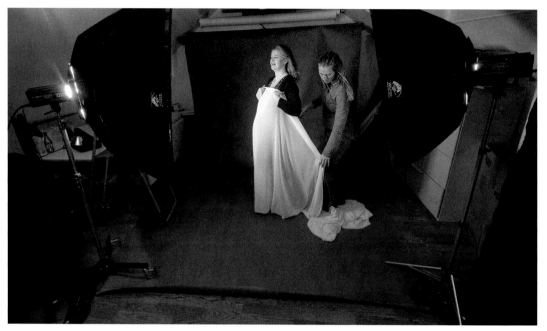

(Above) Going over the elements of the shot before wrapping Talley helped to work out the kinks before she was naked and ensured we were all on the same page. (Below) Clips are your friend. I have said it before, and I will say it again: Get some now.

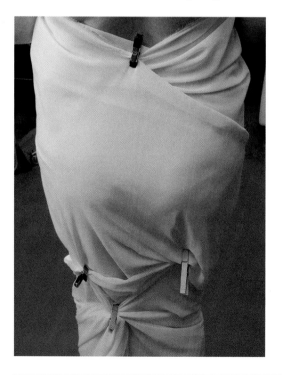

The next image I had in mind required Talley to stand still while I tightly wrapped her in a very long length of white fabric. This might not seem like a big deal to you, but when you are pregnant and your balance is off, standing still and not being able to move your legs is very difficult! Obviously, I didn't want Talley to fall, so I had to shoot pretty fast on the last series. I used a low-powered fan to give just a little lift to her hair, and I had an off-camera assistant billowing the fabric to give it lift.

Again, I used the strip lights with the egg-crate inserts. To give the fabric the feel of an oil painting, I used just enough light on the front to illuminate Talley and then a fill light. These lights really picked up the texture and fluid nature of the fabric, and the Lighttools egg crates minimized the falloff onto the background and gave a nice sheen to the fabric highlights while still being soft on her skin.

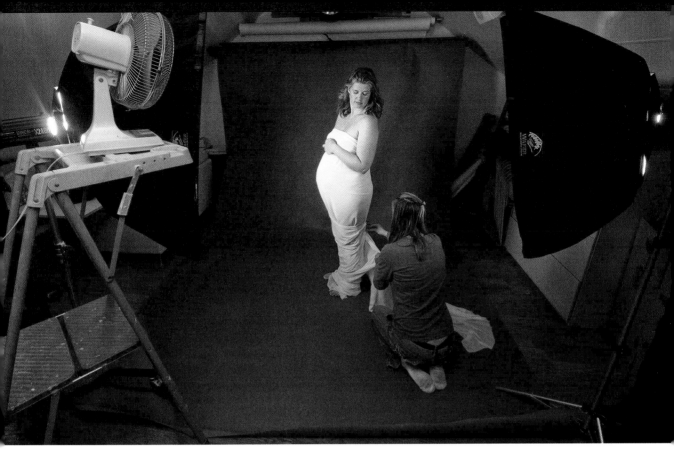

Move quickly and efficiently; standing still and bound is not as easy as it looks.

"*Courage is fear holding on a minute longer.*"
—*General George S. Patton*

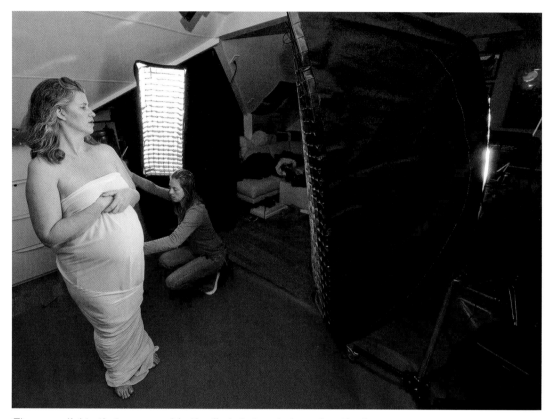

The same lights that were used in the first shot, only turned vertically.

The Mona Lisa is arguably the most recognized portrait in the world, and her smile has sparked many a debate as to its origins. If you do a little research, you will find that virtue and inner beauty were held in high regard in the Renaissance period, and many portraits of that era bear that same signature smile: a calm repose with a hint of happiness.

In the two finished images, I believe you see a very confident and calm Talley in charge of her destiny and that of her unborn child.

(Facing page) Ethereal in its quality, this portrait speaks of angels and mythical beings with its fluid quality.

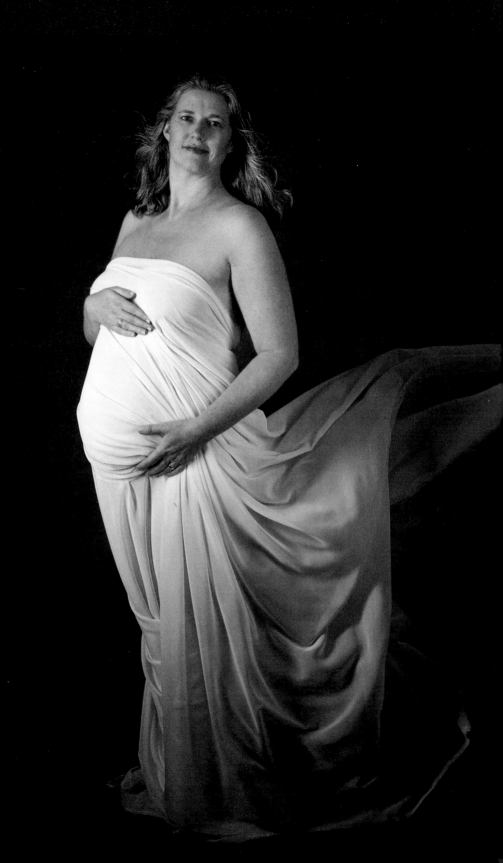

Equipment Used

- Canon EOS-1Ds Mark III
- 50mm f/1.4 lens
- White Lightning 2400
- Plume Wafer Strips with Lighttools egg crates
- Three lengths of fabric

Photoshop Modifications to Final Image

- Used the Burn tool to vignette the backdrop.
- Used the Liquefy tool to slim Talley's thigh at her request.
- Used the Clone tool to remove a crease in the fabric.

"When words become unclear, I shall focus with photographs. When images become inadequate, I shall be content with silence."
—Ansel Adams

9
Robert
and Iris

A child is born. She is beautiful, she is loved, she is special—and she has spina bifida. Iris is a bundle of joy, and if it weren't for the casts on her legs, you would have no idea she is disabled. To her parents, she is nothing but a pure and enchanted miracle to match their older child, who also has spina bifida. Talley and Robert are seasoned professionals when it comes to raising a child with disabilities, but they have no misconceptions about the tough road ahead. The portrait I wanted to do of Robert and Iris was more about strength and resilience than about cute and cuddly.

"The portrait I wanted to do of Robert and Iris was more about strength and resilience than about cute and cuddly."

When I began to formulate ideas for this portrait, I had a number of considerations. First the baby was very young—weeks old—and we would be shooting around her mood and availability, not mine. Second, Robert is a highly evolved personality with passions that he embraces in his everyday life. I wanted to incorporate that into the portrait with the determined innocence of the newborn. Robert loves the Renaissance Festival and is a major participant in the many activities that are part of the festival in the waning summer months. I knew he had period costumes, and I asked him to wear something that would hark back to that period. Iris would be perfect in her birthday suit, but as chance would have it, she, too, had a custom-made Renaissance outfit that was too good an opportunity to pass up.

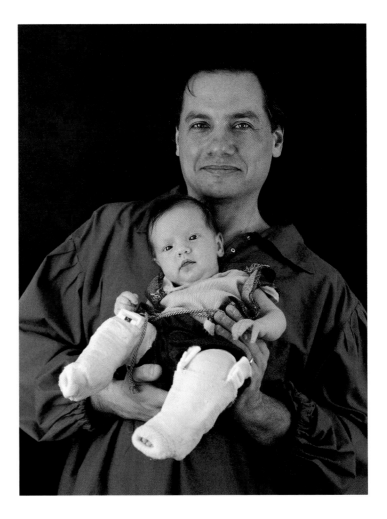

Just for fun, both subjects in full Renaissance attire.

Now to the lights. I wanted to use a continuous light source—a light that is akin to the sun. It stays on and is not a strobe, with a flash of light for each photo taken. A company called Rololight makes a bank of lights that roll up for storage and hang like a curtain for use. You can use them as a standalone light or connect them for large banks of light. What I love about them is that the subject does not blink as much or anticipate the flash going off. I also wanted Iris to be completely comfortable, and I did not want her to be startled by a conventional strobe, which after a few flashes can be bothersome to some people, especially young children.

By placing two banks of the lights at 45 degrees to the subject, you get a nice, soft light and are still able to control shadow and tone, as you can see exactly what you will get. The lights allow you to use slower shutter speeds if you want to capture some movement in a controlled lighting setup. I wanted to shoot close and quietly around the baby but was hoping for her eyes to be open.

NOFEAR

Turn up the heat—babies get cold quickly, as they do not move around enough to create body heat.

Our light source up close. You can add and subtract bulbs with ease to change the light.

My time allotment for this shoot would be short, because even though babies are helpless, they have a schedule, and they run on it like clockwork. Eat, sleep, eat, sleep, repeat—with some cleanup in between. When they are newborn, they do not spend much time awake, which is why you see so many pictures of babies sleeping. I wanted an alert baby interacting with dad or at the very least with her eyes open.

"I wanted an alert baby interacting with her dad or at the very least with her eyes open."

(Above) A gentle light source that puts dad and baby at ease. (Below) Working in close quarters is more often than not the way it is.

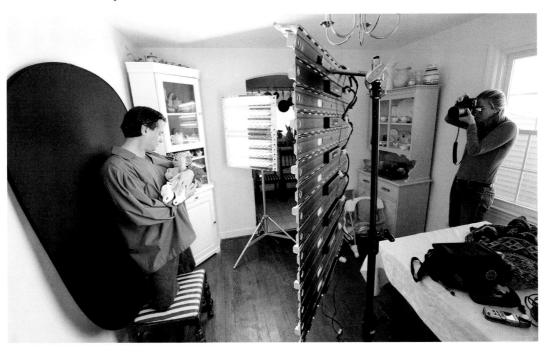

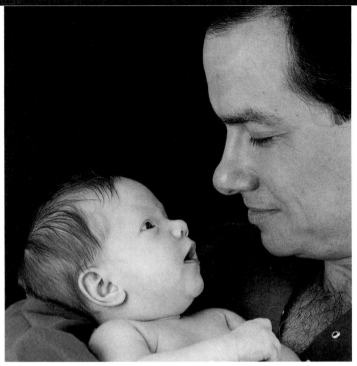

Even at weeks old, Iris knows who daddy is, and he is the perfect distance from her to have a genuine reaction.

Another consideration is that babies cannot see very far at birth—around 6 inches—so I had Iris's mother, Talley, stand next to me and call to the baby. Babies know the sound of their mommy's voice, and they have an acute sense of smell, so I knew she would respond to Talley.

Newborns do not have control over their heads and cannot hold them up independently for months. This meant the poses Iris did depended very much on her father. Robert cradled Iris or held her back against his chest.

As babies get older, they can hold poses longer and have a greater attention span. But Iris was still very young, so I had to work with what she was able to do.

I wanted the finished portrait to have a rich tonal quality to it, so I used a black reflector as the background; it was wonderful against Robert's green shirt.

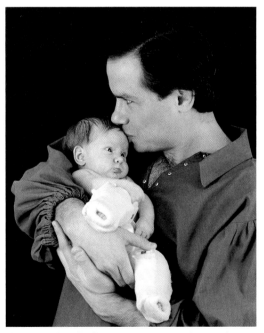

This shot is hilarious, as you never know what babies will do. Just look at that expression!

With any subject, you only have so much time. Iris lasted 20 minutes with one outfit change before she was looking for food and starting to get fussy. Nobody wants a fussy baby, especially when no one in the family is getting any sleep, so the shoot was over for Iris, and she was off to bed—what a life!

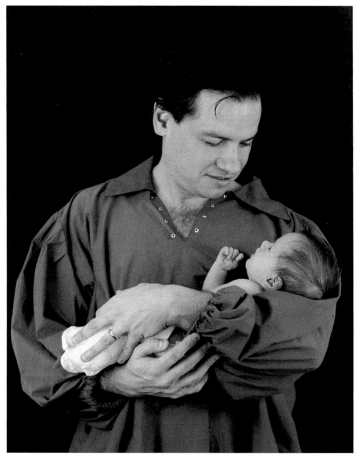

(Above) A classic pose, and I love the Superman hair curl, so I didn't adjust it on site. (Facing page) I love this shot. It is exactly what I wanted. It shows confidence from dad and baby, telling you they will be just fine.

> "*Photography, alone of the arts, seems perfected to serve the desire humans have for a moment—this very moment—to stay.*"
> —*Sam Abell*

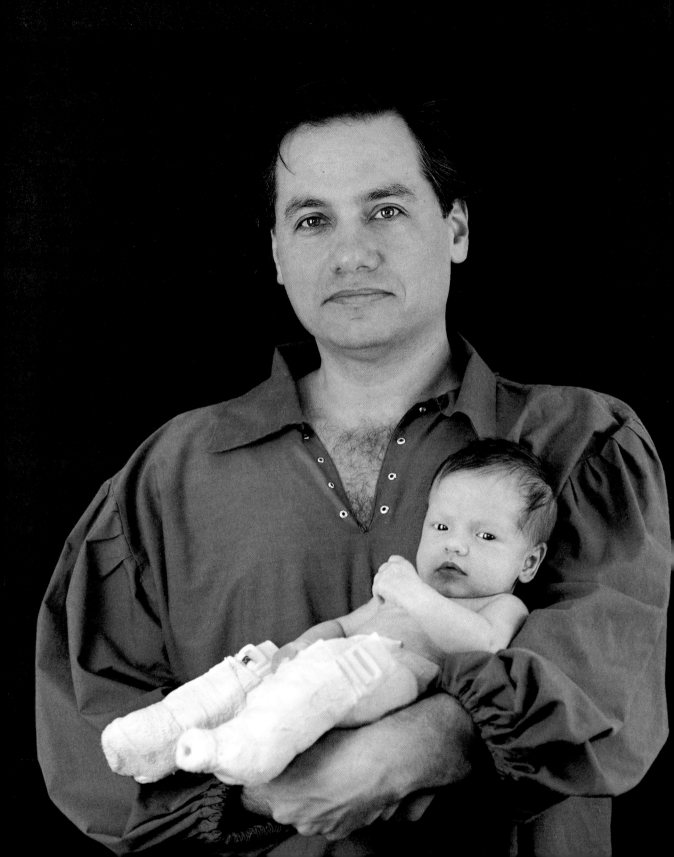

Equipment Used

- Nikon D700

- 85mm f/1.4 lens

- Rololight Pro 25 series

- Sekonic L-358 light meter

- Black reflector as a backdrop

Photoshop Modifications to Final Image

- Saturated the greens.

- Used Patch tool to remove one skin blemish.

"*Photographers deal in things which are continually vanishing and when they have vanished there is no contrivance on earth which can make them come back again.*"
—*Henri Cartier-Bresson*

10 The Original Americans:

Aggie, Keith, and John

There are a noble people who live among us and carry a huge legacy with them, rich in tradition and heritage. These people were stripped of everything that was rightfully theirs and handed a pittance in return. They are Native Americans. There are still surviving Natives who can remember the old days and speak in their native tongue. Just being in their presence is awe-inspiring. Many of them have regular jobs and have assimilated into Western society so seamlessly that unless you know the family history, you would not be aware of their incredible story.

One such family are the Taylors, from their tribal lands along the Siletz River in Oregon: Grandma Aggie Pilgrim; her son, Keith Taylor; and his son, John Harrington. This family is the last in a line that goes back to the last chief of their tribe, before the March of Tears that drove them off their tribal lands back in the early 1800s. Those who survived were relocated to a barren reservation, where many starved because they did not know how to work the land—they were a river tribe living off salmon and the bounty of the forests.

Grandma Aggie is an incredible woman who travels the world teaching Native philosophy and lore to indigenous people and heads of state. She is a force to be reckoned with, at 86 years old, and her long, beautiful braids are nothing compared to her tribal tattoos.

It is very difficult to get this family together—once a year is the only opportunity, when they gather for their tribe's pow wow. Native Americans are a very proud people who generally don't like to have their picture taken, but if it is for a good reason, they are overwhelmingly humble.

NOFEAR

It's permissible to take a picture of a Native person if you ask permission first, but always be respectful of the fact that they may not wish to have their picture taken and that some items and ceremonies may not be photographed at all.

Aggie's son, Keith, is the chief of the Longhorn clan of the Blackfoot tribe in Canada by inheritance, and the hereditary chief of the Siletz tribe by succession—it's complicated! Here is the real kicker: His son, John Harrington, is a well-known professional photographer, a published author, and a good friend, so what do you think will happen if I screw up this shoot? Anyone sweating other than me right now? There's nothing worse than photographing a fellow photographer, because they know if you are in trouble. But you have to know when to go for it, so this is what I did….

We arrived in Oregon on Friday, expecting the family to be at the tribe's reservation, but I learned that Native Americans keep their own time, and it was nothing close to mine. So Saturday morning, John and I went to scout the location for his portrait. I wanted to shoot in the river, as his tribe was so bound to the water. It was the only place I considered, and come hell or high water, that's what I was doing.

The moment of impact—a broken toe. But the equipment was safe!

"That should have been my first warning, but this is fearless photography, right?"

Love that waterproof Pelican case!

First, I had to find an accessible area of the river, down to which I could get all my equipment and John in his tribal regalia. The banks were steep, and everywhere we looked was a non-starter. Then we ran into a young lady from the tribe who informed us that there was one spot used by the tribe, but you had to hold onto ropes to get down to the river's edge. That should have been my first warning, but this is fearless photography, right?

We unloaded all the equipment and John's tribal regalia and headed down the bank like a couple of pack mules. And that's when John broke his toe. His leg disappeared through a hole in the bank between tree roots, and one of his toes bent back on itself. As cool as a cucumber, he looked at me and said, "Pull it back, will you?" Dumbfounded, I said, "Okay" and yanked the toe straight. It is not a sound I ever want to hear again. I was sure he was done at that point, but true to his reputation for getting the job done, he insisted that we take pictures, regardless of how deformed or painful his toe was.

We wasted a lot of precious time scouting and lugging equipment, and by then it was approaching the dreaded high noon. It's not my ideal light, but it's what I find myself faced with more often than not when I'm on location.

NO FEAR

With the right waterproof equipment, there's no reason not to do a water shoot. Just be sure to weigh down your equipment so it doesn't float away!

I took a large Pelican case out into the river and placed many rocks inside so it would not float away. Then I put my battery pack for the Hensel light inside. I wedged the light stand with more rocks and put a strobe on top. I was going to use a softbox but decided to go bare bulb instead. I needed quite a bit of light and I was going to be some distance from John, as I wanted a wide shot but still keeping some compression. After testing my PocketWizards, it was off to help John.

Even a shallow body of water has a current, so weigh down your equipment.

John getting dressed.

The reason I had no help on this shot has a lot to do with the solemnity of John's culture. He had to dress himself, and many of the components of his regalia are sacred. Native Americans wear eagle feathers, which are illegal for you and me. Native Americans place them in the highest of regard, and I could not assist him as he prepared for the portrait, dressing on the river's edge.

I decided to take a few pictures with available light on the water's edge before charging into the water, just in case we met with another unforeseen accident. The high-noon light was giving John's eyes a dramatic, hooded look that added an interesting element to the portrait. As the day's heat started to climb to 90 degrees or more, we decided it was time to go into the river.

(Facing page) Taking full advantage of the rocks as an organic foreground.

NO FEAR

Dress to get wet and get as low in the water as you can without ruining your equipment. Remember, you will dry out, but reshooting is not always an option.

Watching John wade out into the middle of the river was breathtaking, as few people get the privilege of seeing him this way. Native Americans will tell you that when they dress in their tribal regalia, they stand taller and feel empowered, channeling the generations of forefathers who came before them. When I raised the camera to take this picture, it was not John standing before me, but *Its Stan Ski* (He Who Sings by the Ocean), his tribal name. It was exactly what I wanted, and I could ask no more of him.

(Facing page) Available light used to capture nature's reflection. (Above) Behind-the-scenes picture taken by my Nikon D3 on the time-lapse setting.

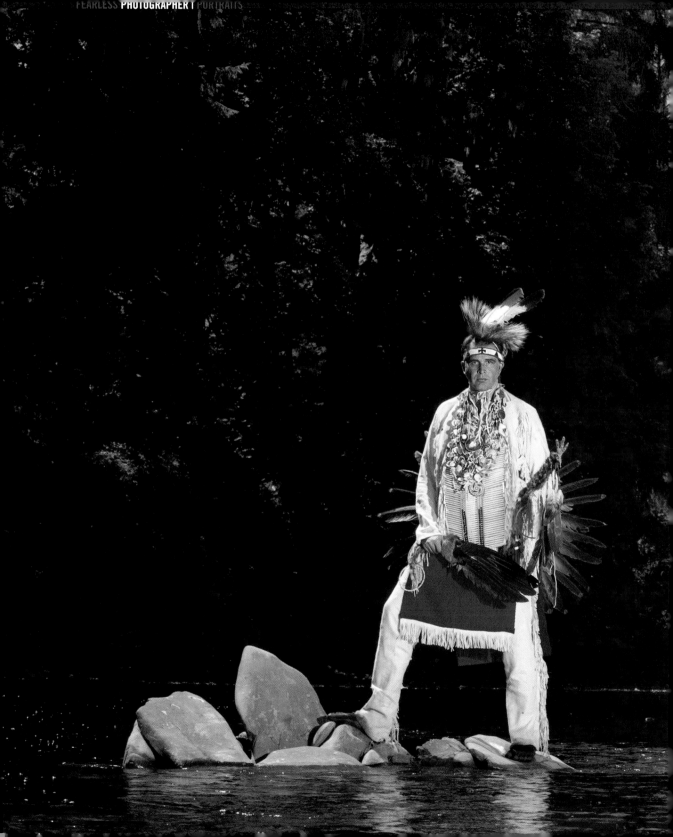

*The final image as
I had envisioned it—
a powerful portrait
that speaks for itself.*

Now the race was on to get all of the equipment back up the bank, into the car, and back to the main arena for Grand Entry. This is where the tribe enters its sacred space to start the celebration for the day. Did I mention it was August and hotter than Hades? John's toe was now purple, but it didn't seem to faze him in the slightest.

(Above) A simple setup. Note the natural color of the grass before adjustment. (Pages 128–129) Two images that I was very pleased with. Because it was August, I freshened up the dead grass in Photoshop.

John's grandmother, Aggie (*Taowhywee* is her Native name), is an incredible woman, and everyone wants a piece of her. I was way down the list in terms of time allotments. I knew I would have to work fast and furious, so I chose available light and one handheld reflector to reflect the sun coming over her shoulders into the front of her, rather than a light and softbox. Agnes Pilgrim travels with her own teepee, so I thought it only fitting to take her picture with that as the backdrop.

NOFEAR

When you're making a portrait of a person of great importance, time will be even more of the essence than usual. Plan your shots ahead so you can accomplish them efficiently.

Native Americans believe in the Creator and are extremely spiritual, drawing on many natural influences in their daily lives. As John brought his grandmother to the spot I had scouted, she was radiant in white brain-tanned buckskin, and it was all I could do to focus the lens. So patient and humble, she posed for me as John held the reflector. As if by holy intervention, the light hit her just right, and I asked her whether she would give thanks to the Creator, as she does often. That was the picture that did it for me, but I have shown you two poses so you can see how a small change can make a difference.

> "*If one has to jump a stream and knows how wide it is, he will not jump. If he does not know how wide it is, he will jump, and six times out of ten he will make it.*"
> —*Persian proverb*

NOFEAR

Don't overthink when you have little time to work with; keep it simple. A reflector is a much underused tool.

The final picture of the day was by far the most difficult emotionally, as it was of John's father, Keith. His native name, *It Spa Eah Wah Ne*, loosely translates to "the person who flies above all the people to protect them." We all grew up on the stereotypical movies showing Indians on horses fighting cowboys, but when you are standing face to face with the real deal, there are no words to explain the feelings of insignificance you have.

Keith Taylor is a man of few words. Trained in tribal law, he works in the tribal courts to solve many disputes within the tribe that are not governed by state law. When Keith speaks in his native tongue, it is like thunder rumbling though the mountains, and you know the instant he looks at you whether he likes you or not.

Shooting feet from some campers. The background is key to the finished portrait.

(Above and below) Shoot high, shoot low, change your angle, and move with purpose.

This portrait was going to happen in a nanosecond or not at all. I had scoured the area for a spot that was not overrun by campers set up for the pow wow, and it was almost impossible to find. I finally stumbled upon a tree that was tucked away behind some tents, and I knew I had my backdrop.

This one was all available light, shooting quickly and respectfully, allowing Keith to be himself with little or no direction, standing next to his son with the enormous tree behind them. I had seconds to get something that conveyed the relationship between them and showed the stature they posses, so I shot high and low to give a different perspective.

Everything I shot that day was special to me because it was a once-in-a-lifetime opportunity. It left a lasting impression on me; I was so privileged to have been given the opportunity to be with them.

"Visual ideas combined with technology combined with personal interpretation equals photography. Each must hold its own; if it doesn't, the thing collapses."
—Arnold Newman

(Facing page) Matching the stature of the tree with the subjects.

Equipment Used

- Nikon D3s

- 105mm f/1.4 lens

- 24–70mm f/2.8 lens

- 70–200mm f/2.8 lens

- Hensel Porty battery-powered light pack

- PocketWizards

- 48-inch white reflector

Photoshop Modifications to Final Image

- Softened selected shadows in the river shot.

- Removed the corner of the reflector that strayed into the picture of Grandma Aggie.

- Darkened and added saturation to the dead grass in the picture of Grandma Aggie.

- Converted one image to black and white.

Part IV

Love: Not All Hearts and Flowers

I think we can all do better in the love-portrait department. Holding hands and looking lovingly at each other has been done, done, done, so let's step it up. Engagement, anniversary, or just plain lust needs to convey real emotion, so in the chapters in this part of the book, I'm going to give it my best shot, and hopefully you'll be inspired. There's no limit on how people express their feelings for each other, and a good photographer can bring that out. Incorporate as many elements of interest as you can through symbolism and props or just plain old-fashioned nudity. I have a couple of cute ideas that I'm dying to share with you, so without further ado, let's get all mushy, bring together all the crazy misfits who are in love, and convince them to express it in a fearless way.

"Light makes photography. Embrace light. Admire it. Love it. But above all, know light. Know it for all you are worth, and you will know the key to photography."
—George Eastman

11 Hearts on Fire: Ray and Angel

I had this idea for a heart of fire years ago, but I needed the right people to make it work. Then I met Ray and Angel. They are a fabulous couple overflowing with passion and talent, and I knew right away this was to be their portrait shot.

I wanted to make a huge heart of fire with two people standing in the middle in a tight embrace. A couple of things probably jump out at you right away—such as danger, danger, and who wants to stand in fire? Come on, what's the worst that could happen?

I decided to test different products to make the heart-and-fuel combination because we need to make it affordable and low tech. If the budget were limitless, we would use a special-effects wizard, and the heart would be made of metal tubing and run on propane. But we had a budget, so here's what I did: I tested shop rags doused in tiki-torch fuel and a separate test with kerosene. I wanted a combination that would burn clean, with no smoke, and long, as I would be using a strobe for my main subject light, and I needed to get at least 10 clean shots before the flames died down. I chose the rags because they are easily molded, and even a loose design on the ground would hold its shape and fuel.

Laying out the cotton rags.

The tiki fuel gave the best flames and a burn time of four minutes, which I figured would give me enough time to get the shot I wanted. Also, the flames, while hot, were bearable for the subjects' proximity to them, and I was confident that unless there was a strong wind, Ray and Angel would be safe.

NOFEAR

Don't be afraid to use fire to help capture a couple's passion. Just take safety precautions and test the effect and your shot before you put the couple in the "ring of fire."

Safety is a big issue when you plan anything with fire. I was not trying to get two-foot flames; a six-inch flame was ample. Obviously, this shot has to be done outside to avoid setting anything else on fire, and you need to do it on a concrete surface. You'll need lots of help to set the heart on fire evenly, and having fire extinguishers on hand is a must.

As much as I joke around, I never take chances with other people's safety. Don't use matches; use fire starters to keep you a safe distance from the flame.

Lay out your supplies so they are easily accessible—especially the emergency equipment.

"As much as I joke around, I never take chances with other people's safety."

Pre-marking the ground where the subjects will stand.

I wanted a lot of height above the subjects on this portrait, so I tested an eight-foot ladder, which ensured that the heart was visible and the subjects were perfectly framed. I built the entire heart and tested it with stand-in models before the actual shoot. Remember: Prior planning prevents piss-poor performance.

In the testing phase, I decided to expose for the flames, as there is little worse in a photograph than overexposed fire. This meant I would be lighting the main subjects at exactly the same exposure settings as the flames, with my strobe. Before lighting the heart, get your main exposure down and the pose you want set, so that once you begin, you are all on the same page. In the case of Ray and Angel, four minutes is not that long, and I did not want to have to redo the heart, even though it was a pretty easy setup.

On the big day, I started the setup two hours before the shoot and had everything laid out and ready to go before I brought Ray and Angel out and got them in position. Having used stand-ins, I had the correct exposure for the subjects and marked the ground so Ray and Angel would not move from their assigned positions.

Making a chalk outline of the heart and adjusting it for perfection.

The flames have the potential to get very hot and even very close to the subjects, as flames will naturally move inward as they burn oxygen; this creates a fabulous visual with dangerous potential. For safety, I had the surrounding area hosed down so that no dry area was within the range of the flames. The driveway on which we were shooting was on an incline, which was perfect for this shot—it created an optical illusion, bringing the top of the heart closer to the camera and giving the heart the intimacy it needed.

Hosing down the area to prevent the fire from spreading.

Light stand sandbagged for safety, and the electrical elements on higher ground to avoid the water runoff before and after the shoot.

Since the flames would be their own light source, I needed only one large softbox to illuminate Ray and Angel, and I wanted to restrict the light dispersion off the edges of the softbox that could fall onto the ground and diminish the flames. To that end, I decided to use the Lighttools fabric grid on the front of the softbox so I would not only have a large diffused light on Ray and Angel, but I would also have that same light be directional, with little fall-off.

Before lighting the fire, I placed Ray and Angel in the heart and shot the pose that I wanted without the flames. This way, they had relaxed expressions on their faces, and if they became concerned during the hot part of the shoot, I would have an expression I could work with in Photoshop. If you have the slightest feeling that you will need to combine shots in Photoshop, be sure to use a tripod so that every image is the same. Save yourself the trouble up front instead of hours later.

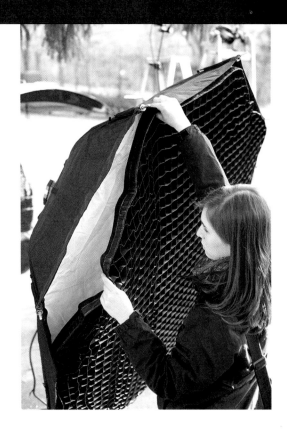

(Top right) Attaching the Lighttools grid onto the softbox; it adheres with Velcro. (Below) The camera clamped to the ladder to ensure that each frame aligns with the others, in case we have to combine several after the shoot.

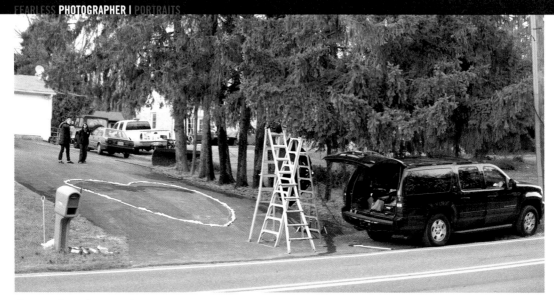

An overview of the entire setup.

NOFEAR

Take a few shots of the couple without the flames, just in case any nervousness shows on their faces during the actual shoot. You can always splice together different images in Photoshop to create the final shot.

(Below) Pouring the fuel onto the rags before ignition.

Then it was time for the fun part! We lit the top of the heart first, as it was the farthest from the subjects and would go out the most quickly. As with all perfect plans, though, things went a bit wrong. Three people tried to light the heart in unison, but only certain parts caught. Tiki oil starts to freeze at temperatures below 45 degrees, and the ambient temperature was close to 32 degrees! Thank heavens for the blowtorch. The only problem was that we only had one torch, so the heart was lit in sections. However, it turned out to be for the best, because when the front of the heart was lit, it got hot very quickly.

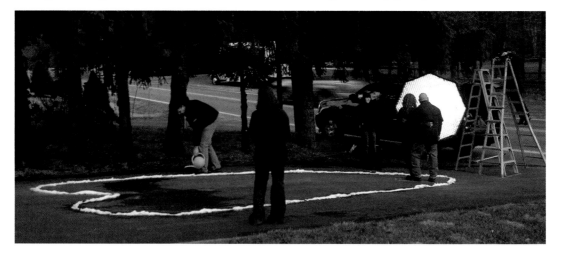

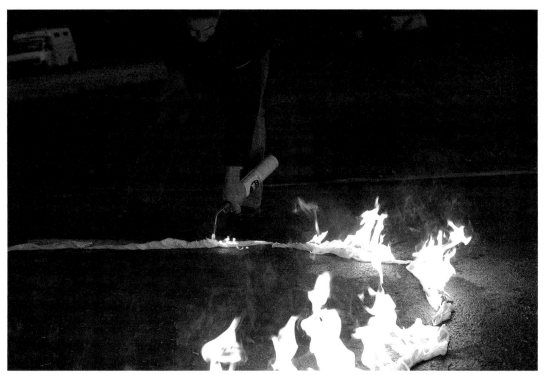

Lighting the top of the heart with the blowtorch.

During our pre-shoot safety chat, I had told Ray and Angel that if the heat got to be too much, they should exit to the rear (or top) of the heart, as the flames would be dying down there the fastest, and that's exactly what happened. I continued to shoot as the heart was lit. In the final image, the shot of Ray and Angel I chose was taken during the height of the flames. True to form, they were a poised and in-control couple during the whole process.

It really didn't require much in the way of manipulation to get the final image, as the flames were real and Ray and Angel were present the entire time and not added afterward using Photoshop. Only a few shots were spliced together to make the final portrait, and that was just to add a bit more flame to areas that had burned down a bit. It's an all-time personal favorite of mine.

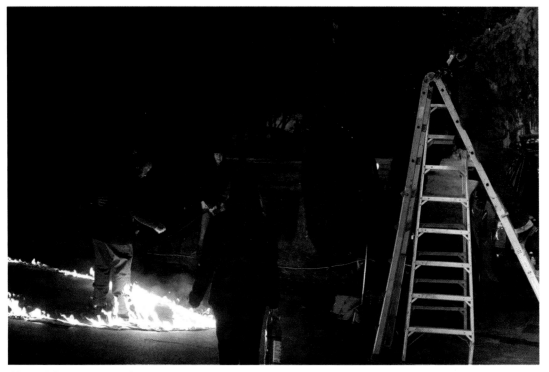

(Above) Everyone standing by with fire extinguishers and water hoses. (Below) Ray and Angel don't bat an eye as the flames get closer. (Facing page) The final image in all its fiery glory. Note how intimate the heart is because it was shot on a hill.

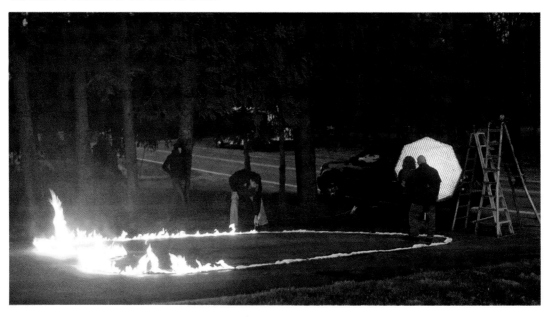

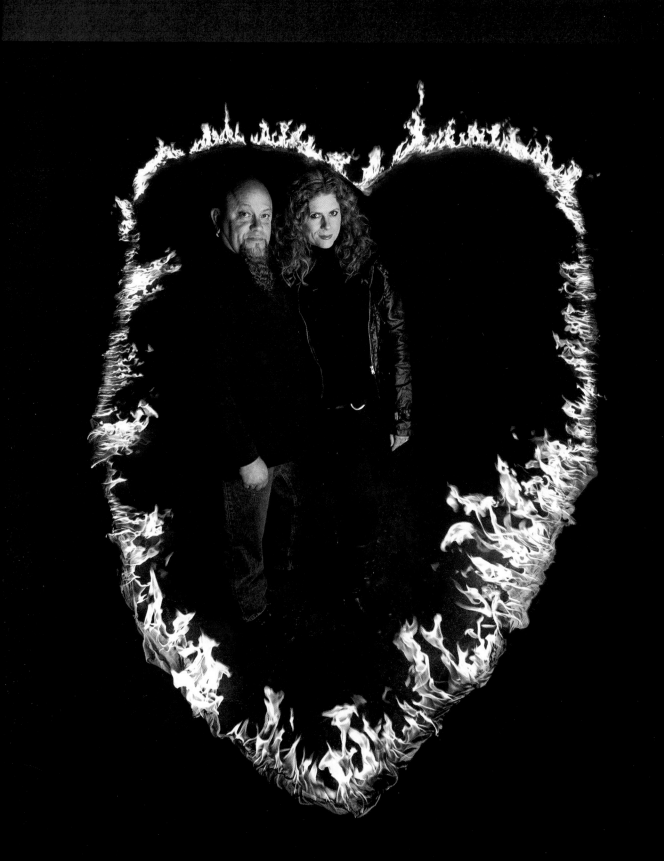

Equipment Used

- Nikon D700

- 24–70mm f/2.8 lens

- PocketWizards

- Hensel 3000 AS asymmetrical power pack and one head

- Chimera 57 softbox with Lighttools grid

- Eight-foot ladder

- Cotton shop rags

- Tiki oil

- Fire extinguishers

- Sekonic L-358 light meter

Photoshop Modifications to Final Image

- Selected the top of the heart from one frame and added it to another.

- Used the Clone stamp for a small area of flame to fill the hole in the heart.

"I always thought of photography as a naughty thing to do—that was one of my favorite things about it, and when I first did it, I felt very perverse."
—Diane Arbus

12 Nothing but Chapstick:

Lindsay and Greg

This couple is so darn cute I could die! They are at the perfect age with perfect skin and are blissfully in love. Ah, the joy of being a young adult, living in your first rented place, and spending your own hard-earned cash but still phoning home on the weekend.

Lindsay needs no makeup because she is perfect—hate her, but she put on just a hint of eye shadow and some mascara. Girls will be girls…. Greg is just Greg, but we tousled his hair and hit him with some hairspray to make him feel special. I purposely had Lindsay pull back her hair to be more polished and stylized than Greg to create a yin-and-yang effect in the portrait and to reinforce the feeling that men are unaware of their appearance.

NOFEAR

Hair and makeup are an easy way to enhance a shoot. Don't be afraid to suggest a different look—girls love to be girls.

I wanted a look and feel for their portrait that was fresh and clean, with a pure light source and an uncomplicated background so the subjects would hold center stage. Because Lindsay has such a beautiful face and a great jawline that I wanted to accentuate, I chose a ring light.

Ring lights are all the rage for fashion photographers who want the shadows to appear all around the subject and have a sharp look and feel to the face. I personally like the fact that the light and camera are in the same place and the light is moving with you. You essentially become the light source, since it is moving with you, so you have to watch your exposure, because going in close will change your f-stop dramatically.

I wanted to show you how easy it is to change the look and feel of things quickly on set without too much trouble, so I started out with one light on the white seamless to give me a perfectly white background and balanced the ring light with that. This also meant there would be no shadows on the background, which usually is the hallmark of a ring flash. I had in my mind a portrait that was very tight and poignant with just a simple kiss to the forehead by Greg. The message is very strong in this pose and needs nothing in the way of explanation, but I'm sure you can see the complete contentment in Lindsay's face. This kind of portrait is the most satisfying for me, as you have an instant reaction to the image. It evokes a warm and fuzzy response; her mother will like it.

(Left) Don't be intimidated by a ring light. It's not just for fashion; it's another tool in your box. (Facing page) A powerful close-up of a pure moment.

Next, I wanted a slightly more provocative pose that would end up very tight and close—the lip bite. Many a lover has nibbled on his partner's lip during a romantic exchange, and it makes a nice vignette, a captured moment, similar to the ear nuzzle. This one took some time to nail, as my subjects dissolved into laughter on every attempt!

Don't be afraid to shoot tight vignettes from the larger portrait session.

For me the color image was not as sophisticated as the black-and-white version.

This session was always going to end in black and white, but I have included the color so you can see the difference it makes. Especially when a decent amount of skin is included, I personally think black and white is the preferred medium, but it is all subject to change. By shooting in color, you keep that information should you change your mind.

Backgrounds play a major role, too. I placed a black reflector behind Lindsay and Greg so you can see how the shadows increase when there is no white background for the light to bounce off. The white background gives you added fill light in the areas of Greg's chest and a slight hair light, but the black absorbs everything. It's the photographer's choice, but an important one to consider.

(Above) Working in the studio with just the ring light and one background light (at top). (Right) The black background stops the light dead in its tracks, building shadows on our subjects' features.

N**O**FEAR

It's all in the crop. No one was naked in this shoot, but it looks that way. Lindsay still had on a tube top!

Ethereal backlight gives this portrait a heavenly feel.

> "*My* job as a portrait photographer is to seduce, amuse and entertain."
> —Helmut Newton

During our setup and light check, Greg had made a face at Lindsay that resembled a lion roaring. It appealed to me, but I wanted to enhance it with light. So, I took the background light and placed it behind the white seamless so it would shine directly on my subjects and create an ethereal light; blowing through the seamless also would soften the light. By making that light brighter than the ring light, you can have varying degrees of light bleeding through the subjects.

I just adjusted the background light until I had a look I was happy with and then positioned Greg so the light was spewing out of his mouth. The defiant look on Lindsay's face leaves you wondering who is winning the battle of the sexes. To me, this portrait is very powerful in its simplicity but amped up by the lighting. Shooting with the same light and re-creating the kiss makes the portrait angelic! It is interesting how the light can change everything.

Interesting how the light can add so much to a pose. This one evokes rage.

For the last look, I took a white fur rug and used that as the background. It added a touch of texture behind them for a different feel.

NOFEAR

Never lock yourself into one background or idea on a shoot. If you have the time and the clients are relaxed, try everything you can, because redoing it later is not an option.

The fun begins in post-production, when you begin to adjust for the final image. I'll be the first to admit that time in front of the computer is a complete drag for me, and I try to limit it whenever I can. I'm always looking for ways to shorten the time and find different software that will make my life easier.

Converting to black and white is always a disappointment for me because I am old enough to remember film. For those of you who jumped straight into digital, this may not make any sense, but the rest of us miss the tonal joy of a silver halide print. But apparently I am not alone, because now there is some great software on the market that re-creates many of the nuances and qualities of the different black-and-white films of yesteryear. In short, you can apply the film of choice to your image and adjust the grain and tone as well as a myriad of different film-development techniques. This is incredible for me, as I can barely turn on the computer.

I chose a product by Alien Skin called Exposure 3 to work on these images. The nice part is you can try this product free for 30 days before you plop down your money for it, but it is well worth it to take your business to the next level of creativity. It works in tandem with Photoshop, so after you apply your film of choice, you can adjust further through Curves and so on to get the image right where you want it. In the tight-embrace portrait, I added a layer and adjusted the shadows just a hair to give the image a little more depth overall.

NOFEAR

The sky's the limit with your creative ideas now, so dive right in and experiment. Nothing is permanent, thanks to the digital age.

> "*An essential aspect of creativity is not being afraid to fail.*"
> —*Edwin Land*

(Facing page) Cropping tight on the subjects further enhances the close embrace.

Equipment Used

- Nikon D700

- Nikon 85mm f/1.4 lens

- Hensel ring light

- White Lightning 2400 with reflector

- White seamless

- Black reflector

- Two yards of white fur fabric

Photoshop Modifications to Final Image

- Converted to Agfa 100 film with Alien Skin software.

- Adjusted shadows in Photoshop.

- Used Clone stamp to remove flyaway hair.

"*Most things in life are moments of pleasure and a lifetime of embarrassment; photography is a moment of embarrassment and a lifetime of pleasure.*"
—Tony Benn

13 After 8 p.m.

Today's youth think they have the monopoly on love, sex, and all things steamy, because they know everything! Those of us who are over 40 know better—and then some.

The concept for this shot is simple: Every woman loves a man in a tuxedo, and every man loves what his lady is wearing underneath the evening wear. Going out and living the James Bond lifestyle doesn't happen often, but it is the closest we come to knights in shining armor and fair maidens. With that in mind, I wanted to create a hot little portrait of a couple I know. Then, as with all my best ideas, something went wrong—the couple fell through. I still wanted to get the shot done, so for a good laugh, I decided to do it myself.

After convincing my better half that we would not look fat and old, I set in stone a time approximately 20 minutes after I told him, so he couldn't back out.

I wanted the final image to be black and white, but I shot in color so you could all have a good laugh at our sickly complexions and graying hair.

Ma and Pa Kettle—the ugly truth.

To keep it simple with the lights, I went with a large soft-box to fill the wrinkles and a silver reflector on the side to add some pop to the black tuxedo. I wanted a sultry look overall, with me wearing the evening shirt over my best underwear and super-expensive stockings, to freak out my kids. There were no assistants on this one—they all ran for the hills. So I set off the camera using my trusty PocketWizards.

I cannot stress enough how a good application of makeup can change the look and feel of a portrait. I have included the horrendous "before" shots of me without makeup, doing the light test, so you can see the full effect of war paint.

Including a standardized color chart in one shot will nail your color balance later and is such a simple tool to utilize. We used the Macbeth ColorChecker, but there are many brands from which to choose. By choosing something with a known grayscale, you can use that gray spot to set your neutral point in Photoshop, and then there's no debate about whether there is a color cast to the image.

"*Don't look back, darling; it detracts from the now.*"
—*Edna Mode*

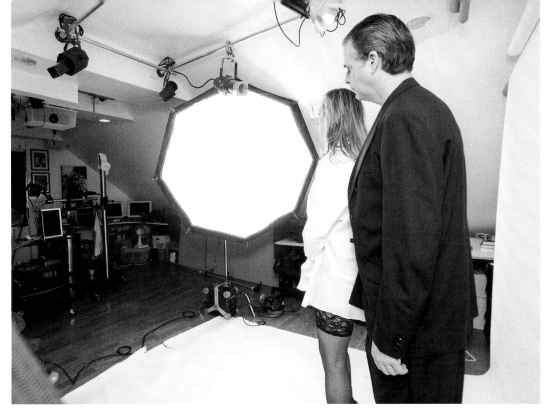

(Above) A simple lighting setup triggered by a PocketWizard hidden in my attire. (Right) A Macbeth ColorChecker lighting test ensures that your skin tones are truthful.

A simple white seamless as your background is all you need to make this shot. There is so much going on with the subject matter that you don't need any embellishments fighting for your attention in the final image.

Most couples are excited to try this type of portraiture, but there are some things you can do to make it fun. Music is a must, as it gets people moving and grooving. As the natural flow of couples dancing plays out, you see the best shots revealed. When couples are dressed provocatively, they take on that persona and really start to let loose and live the fantasy.

"A good application of makeup can change the look and feel of a portrait."

A provocative pose but not there yet.

A playful crop that centers all the attention on the female.

Couples portraiture can segue nicely into a solo shot of one of the participants. Always think beyond the original concept.

Sometimes a goofy shot may be the most fun because of the contradiction between the attire and the pose. Also, remember that unless people are really making fun of themselves, be cognizant of areas of the body that may not be flattering and play up the good ones. This portrait can go either way, depending on your subjects—sultry and sexy or fun and fabulous!

As light as a feather, the playful pose is more fun for me than for him.

Normal is boring. Shake it up—you have nothing to lose but a lost opportunity if you don't try.

We had fun making this work, and we have a 16×20 of the best shot hanging in the bedroom to ward off intruders!

(Page 170) This pose pulls together the couple and is a strong composition, but I think we can do better. (Page 171) A subtle change in hand position changes everything, and now we have a pose that conveys a symbiotic relationship yet an über-confident female.

Equipment Used

- Nikon D3

- Nikon 50mm f/1.4 lens

- Chimera 57 at the 5-foot diameter

- Sekonic L-358 light meter

- PocketWizards

- 4-foot silver reflector

- 9-foot white seamless

Photoshop Modifications to Final Image

- Mind your own business. That's what I look like—I work out!

- Converted to black and white.

Part V

Extraordinary Portraits: Push Your Limits

Some portraits don't fit into a neat category—for good reason. Some require you to swim, tread in manure, wrangle hundreds of people, or even work with fast cars.

Who doesn't love a fluffy kitten or a cute puppy? Ah, let's work with animals. It's got to be better than working with kids, right? Yet again, you can do so much better than the cookie-cutter pet pictures you see every day. Try to capture the spirit of the relationship in a new and interesting way that will leave a lasting memory for the owner.

How do you feel about large groups of people? Do they make you nervous? How about time constraints—do you work well under pressure? If so, you're going to love group portraits.

Can you hold your breath and, if so, for how long? Do cameras and water mix? Absolutely!

And who doesn't love fast cars and mysterious men? This section is about mixing things up, and hopefully one of these shoots will bring out your fearless nature.

I can't wait to start, so let's go get bitten by large animals, fight fading daylight, and spin some wheels in the pursuit of the perfect portrait!

"*A* *photograph is neither taken nor seized by force. It offers itself up. It is the photo that takes you. One must not take photos.*"
—Henri Cartier-Bresson

14 Lyndi and Clyde: Beauty Tames a Ton (Literally)

There is an incredible bond between horse and rider, but I have always been in awe of women who can tame the beast and bring it to its knees. Meet Lyndi and Clyde. Clyde is a thoroughbred with a lineage to match his reputation. Lyndi is a horse trainer with a reputation of her own. When their paths crossed, it was a match made in heaven. Clyde jumped out of his previous owner's field, and that's when Lyndi got him. He was too much for most riders, but Lyndi, a very petite lady, showed him who was boss.

I had mentioned to Lyndi that I wanted a shot of her bareback on Clyde, wearing not much but underwear, and she said, "Sure, why not?" See—you just have to ask!

Months went by, and I had yet to shoot the portrait of them, and then I got a call from Lyndi telling me she had a new horse that she thought would be even better, and I should come over that week and shoot. And so I went—after a stop at the store to get mints for the talent!

I knew the farm pretty well, so I chose equipment that would be stable and would give me a huge, soft light. Working on farms and in rural areas comes with its own challenge, as the terrain is rarely flat and can be wet, so do the legwork and scout beforehand if possible. If not, bring everything and prepare for the worst.

When working with animals, you must be prepared for anything. There is no such thing as a perfectly behaved animal. It probably has never seen you and your strobe, and if the animal doesn't like the strobe, you better hope you can convince it otherwise—especially when it weighs 2,000 pounds!

Clyde gets familiar with my camera. Never underestimate the intelligence of animals.

"When working with animals, you must be prepared for anything."

I always introduce the animals to the equipment—let them smell it, encourage them when the strobe goes off, and then ignore it. A good owner/trainer will know when the animal is stressed and will take appropriate action to calm it. However, the last thing you want is your softbox blowing over or falling down, so sandbag it or have an assistant who does nothing but stand next to the light and hold on tight. A spooked horse can move faster than you and will definitely leave a bigger mark.

(Above) Weighted and sand-bagged; I took no chance that equipment could fall over. (Right) Inserting the internal baffle that ensures the light is even across the entire softbox area.

NOFEAR

Take the time to ingratiate yourself with the animals you are photographing.

On arrival that day, I met Lyndi's new baby, Spydee, and she was right—he was gorgeous but also young. On closer inspection, I realized he was a stallion and only three years old. This is classic Lyndi—always pushing the limits. For those of you unfamiliar with the traits of a stallion, think four-year-old twin boys with wooden blocks and no discipline, and you have the demeanor of a young stallion.

I inquired whether he was broken (that is, trained to take a rider's instruction) yet, and she gave me an impish grin that meant, "Barely!" We agreed to try him first with her fully clothed, as he was very much an unknown entity. So out he came, looking every inch a stallion, and he proceeded to glare at my softbox. Next, he decided to bite me when I turned my back—not hard, but enough to tell me I was in for a good time.

(Above) It takes some work to get the big softboxes together, but it is worth it. (Below) The softbox is positioned pretty high above the subject to illuminate horse and rider.

The freedom to move around when using PocketWizards is priceless.

Lyndi mounted her steed, and he was as quiet as an old man. He let me get off a few test shots, and then he got bored with the whole thing, reared up with Lyndi on his back, and threw a tantrum. She was having none of it and looked as if it was just another day in the trenches. I, meanwhile, had stopped breathing.

So after a brief meeting of the minds, we decided that it might not be the best idea to shoot with Spydee, as she would be wearing next to nothing, bareback, and she was worried he might get hurt free-wheeling around the paddock. Horse owners!

Throughout this whole process, Clyde had been looking out of his stall, watching the whole thing, and he was ready to step in and save the day. Secretly, I was very happy because he is my personal favorite. He was such a gentleman and let Lyndi do anything she wanted—that was borne of a long and trusting relationship.

Lyndi and Clyde make a great couple, but the pose is not perfect yet.

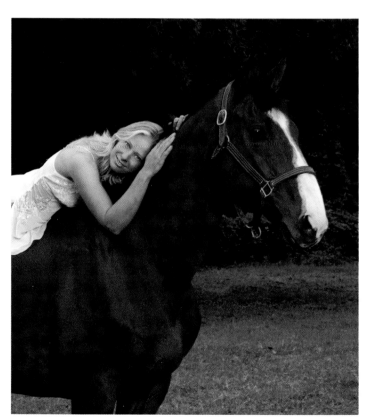

The hand placement is better in this tight crop and has a more relaxed look and feel.

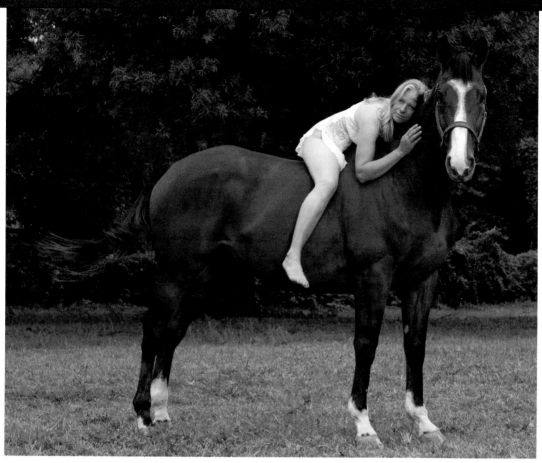

Clyde looking at the camera makes the pose, adding strength to the softness of Lyndi.

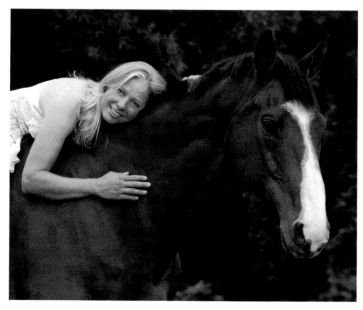

Clyde's head position is great in this tight shot.

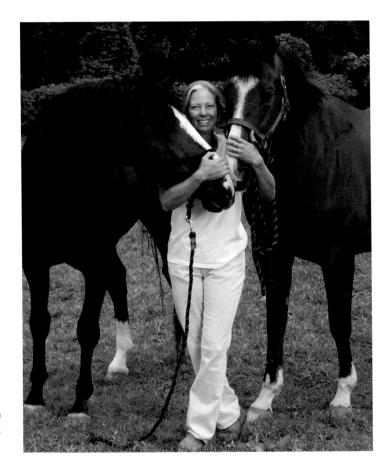

The young stallion (Spydee) and the old man (Clyde), both in love with Lyndi.

I had plenty of time to use a number of lenses and try out interesting poses, but I have a strong feeling I will be going back for round two with the stallion. (And Clyde got all the mints.)

(Facing page) My favorite: horse and rider in a fun pose that shows their special relationship.

Equipment Used

- Nikon D700

- 50mm f/1.4G lens

- 85mm f/1.4G lens

- Hensel Tria 3000 AS asymmetrical power pack with one head

- Chimera 57 softbox

- Bogen boom arm

- Sandbags

- Sekonic L-358 light meter

- PocketWizards

Photoshop Modifications to Final Image

- Selected skin tones in color range.

- Created a skin-tone layer and added a Gaussian blur.

- Changed the blending mode for the layer from Normal to Luminosity and reduced it to 40%.

- Removed imperfections in the horse's hair using the Patch tool.

- Removed distractions in the background using the Clone tool.

"*Photography, as we all know, is not real at all. It is an illusion of reality with which we create our own private world.*"
—*Arnold Newman*

15 Agent C's
Hot
Wheels

The relationship between man and machine is unfathomable to most women, but we understand the connection and thrill factor—we just choose to roll our eyes at it. That being said, I recognize the great opportunity it presents for pictures.

I had an idea to shoot a car in full burnout, smoke billowing from the rear tires as the driver looks directly into the camera with a confident gaze. Immediately, a few nagging safety concerns jumped to mind, and I knew I needed someone who knew what he was doing. A number of years passed, and a friend of mine with a burning passion for bikes and cars said he was up for the challenge. Hooray, let's go—this was going to be lots of fun!

My friend owns a silver Corvette with a few, shall we say, modifications, so I was confident that I was going to get a great picture. The car has gull-wing doors, and that in itself is a great visual, but my friend wanted to up the ante just a little. I asked whether he had any lady friends who he might want to incorporate in the portrait, and he said he had an idea to put one in front of the car, depicting a vain attempt, pictorially, to stop the car with one finger.

This was great stuff! We had a subject with great ideas who was invested in the project, so now we could sweat the small stuff. My friend—let's call him Agent C—has, shall we say, a sensitive job description and an even more difficult schedule, so making this work would take planning.

We needed a location that was private, had a power supply we could plug our lights into, and was large enough for a car and all of my equipment. We nixed our first choice, which was outside, because the ambient temperature was in the 20s, and there was snow on the ground. So we rescheduled for two days later, and Agent C came up with an underground garage facility in an undisclosed part of the country.

NOFEAR

If the background where you're shooting is dull, try shooting a different background and layering the images in Photoshop. Nothing says that the model you shot in front of a plain wall can't appear to be standing on the rim of a volcano in the final image.

The best pictures come from challenges, and the challenge here was to make the shot interesting in a gray, industrial building. I spend many nights going over shots in my head, and this one was no different. I could go with a grungy background and hope the polished look of the car and subject would be enough to pull it all together, but as the day got closer, I knew that even though I am a purist, this shot needed a green screen and a new background.

"Photography deals exquisitely with appearances, but nothing is what it appears to be."
—Duane Michals

Even an underground garage can be a studio.

Individual lights work in unison to produce the final lighting setup.

I had recently had a four-hour layover in Las Vegas, and I had shot some long-exposure pictures of the lights while walking the Strip. Now I had just the shot to put behind them! All I needed to do was figure out my lighting. Seriously, I have to think it through, and so should you—try something different, and don't get stuck in a set lighting pattern. Take a chance now and again!

NOFEAR

It's easy to get comfortable with a lighting setup and rarely vary it. Instead of falling into that trap, force yourself to experiment with different lighting setups to see what sort of results you can achieve.

"The best pictures come from challenges."

I decided on five lights—two strip-light softboxes, one beauty dish, one silver umbrella, and a blue gel. I didn't want a flat light; I wanted some shadows on the faces to give definition, and I wanted a clean, fluid look to the car to make the paint shine and accentuate the custom wheels.

Mixing up the light sources adds some issues, but that's where your trusty meter comes in. You do have one, right? After you set the lights, meter them individually so you can get each one exact and then turn them all on for a final metering. I wanted to shoot at f/8 with a little extra light on the main subject, who would be seated in the car for the main shot and backlit by a blue-gelled light.

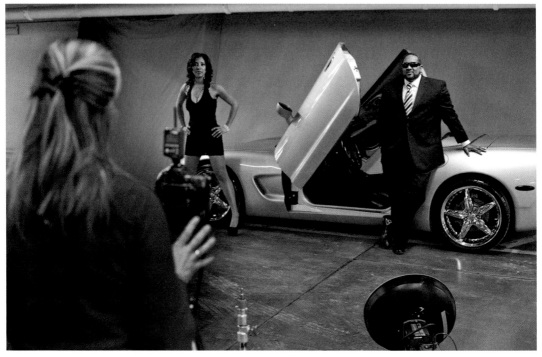

Communicate, communicate, communicate and then do it again. You have to build a rapport with your subjects, especially when they don't see what you're doing. They have to trust your vision.

The best plans are subject to change, and after getting the car in position and setting the lights, Agent C was unsure of the feasibility of the burnout, as the surface was so slick in the garage that the car would not get traction. So I built the shot from scratch on site with different poses. This is the best part for me—mixing things up, being flexible on site, and letting the moment and the subjects bring out the shot.

Reviewing as you go is essential when you're working with many lights and changing poses. Subject-to-light distance is everything, and when working with gels you have to make sure you don't get contamination from light bleeding over onto areas of the picture you don't want colored! Using gobos can preclude light from going where you don't want it, and sometimes a gobo can be just a few inches in size. A great tool is Black Wrap, which is a black, non-reflective tinfoil.

"This is the best part for me—mixing things up, being flexible on site, and letting the moment and the subjects bring out the shot."

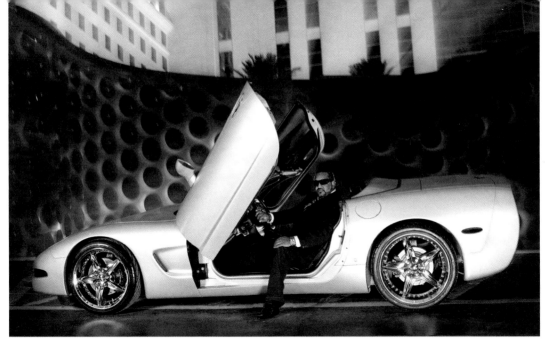

A clean portrait showing man and machine, but not the only pose. Don't get locked into one idea; keep looking to improve.

I used a nine-foot green paper background and a more flexible cloth for the front of the car, to drape the floor. I chose the blue gel to complement the silver of the car and give a sci-fi feel to the picture, knowing I was going to use one of three Vegas shots that would work with that color range. Also, with the reflective quality of the car and the green background so close, I knew there would be some color contamination in the silver paint. I took that into consideration when I chose the new background.

The rear light with a blue gel adds a creative and surreal element to the shot.

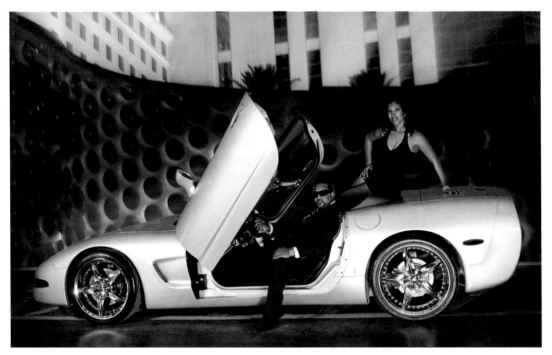

(Above) Eat your heart out, international spies—a very sexy pose. (Below) Both subjects making contact with the car through the same hand positioning makes a strong statement.

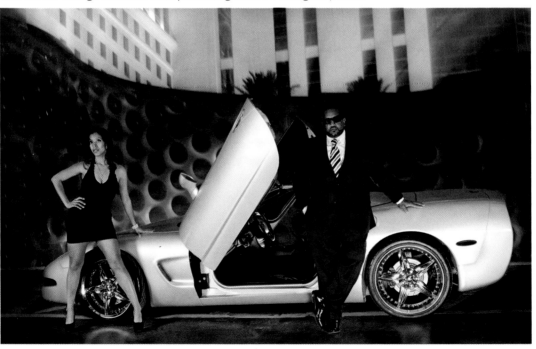

*"Composite portraits are absolute quackery!
What next, composite landscapes?"*
—Anonymous, The Photographic News, *London, 1888*

I shot many different poses with the stunning Ms. Jennifer, our beautiful female subject, and I even took some solo shots of Agent C before I called it a day. And then, that little voice in the back of all male brains started to speak, and Agent C suggested that maybe we should give just one burnout a try! So I shot Jennifer in her pose first and then allowed the burnout to happen without her in front of the car, for obvious safety reasons. I am not going to reveal the secret behind a good burnout for fear you will all run out to the parking lot and try it; but believe it or not, water is involved. Who knew?

Now comes the fun part: I had to choose a shot and finish it with the wizardry of Photoshop. As you know if you read my introduction, I don't like to overuse Photoshop; I believe everything should be done in camera where possible. That being said, this shot was built around the premise that we would create the final image in post-production since we were using a green screen to begin with.

To give you some idea of the work involved, it took approximately 12 hours in front of the computer to get the final images done. I am not going to list every tedious keystroke, but I will tell you that it involved multiple layers built around one main static shot of the car. Once the tires start spinning, the car actually moves downward, and in the shots where the driver is standing, the car moved up without the weight of the driver. All of these things matter when you are stitching things together, hence the importance of the tripod.

(Pages 196-197) My favorite shot, very classy and powerful. (Pages 198-199) A great composite shot that is a grown man's dream come true.

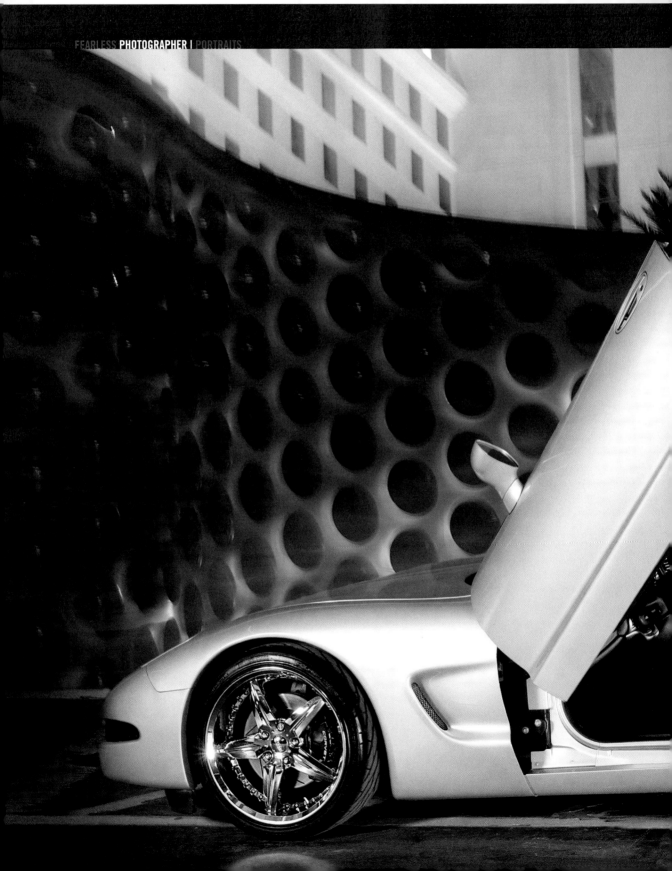

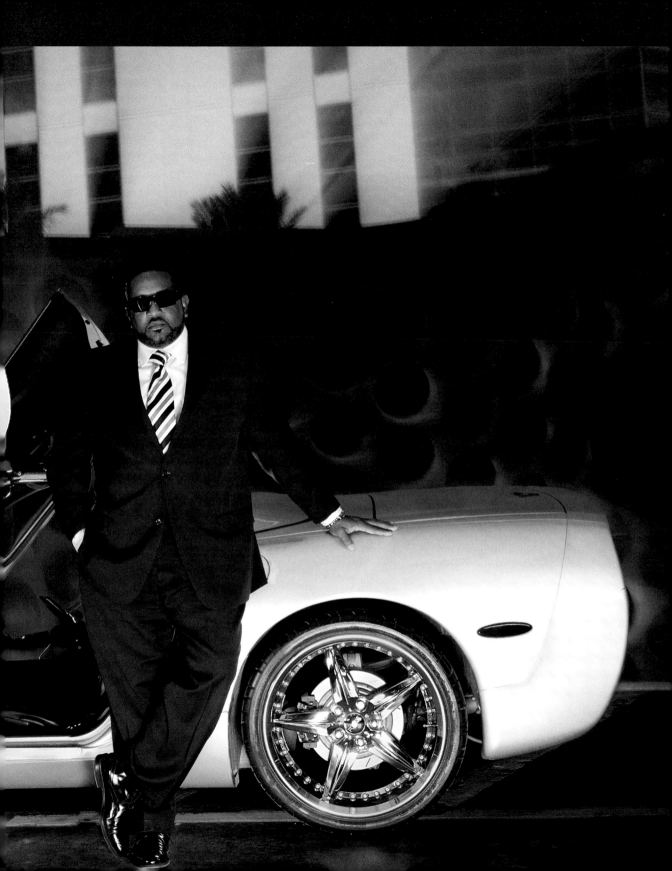

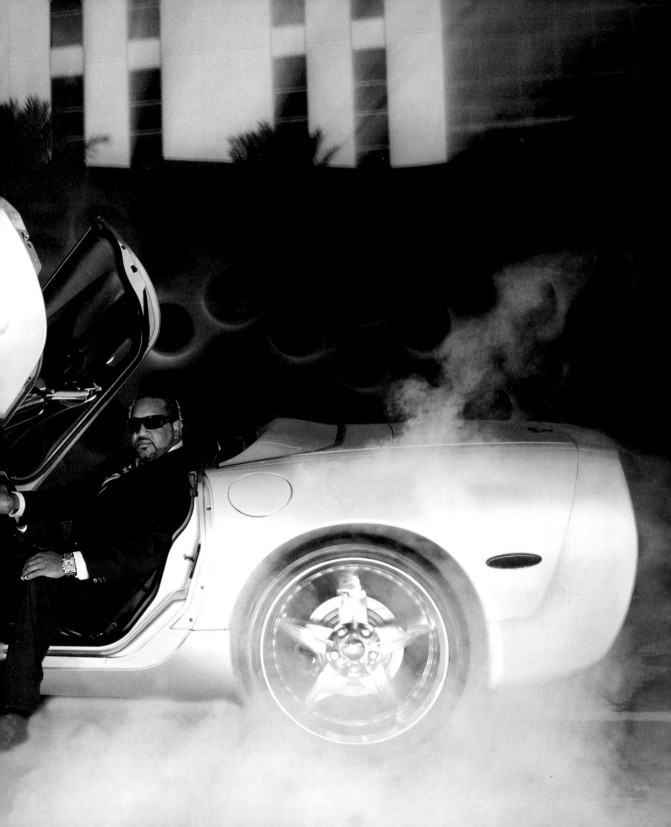

Equipment Used

- Nikon D700

- 35mm f/2 lens

- Five Hensel Velas and five EHT-3000 heads

- Plume Wafer Strip 100 softbox

- Plume Wafer Strip 140 softbox

- 30-inch umbrella

- 20-inch beauty dish

- Blue gel with reflector

- PocketWizards

- Sekonic L-358 light meter

- Black Wrap foil gobo material

- Savage Tech green 9-foot backdrop hung lengthwise

- 9×20-foot fabric green screen

Photoshop Modifications to Final Image

- Used Color Range to select the green screen and remove it.

- Added the background layer.

- Flipped the background in Transform on the new layer to add reflection to car.

- Merged frames to incorporate smoke onto the static car.

- Merged frames to incorporate the female in front of the moving car.

- Used Dodge and Burn to add subtle shadow work.

- Used Color Range to match the background to the blue gel.

"Do not quench your inspiration and your imagination; do not become the slave of your model…. If you hear a voice within you say 'you cannot paint,' then by all means paint, and that voice will be silenced."
—Vincent van Gogh

16 H$_2$O: Endless Possibilities

I love, love, love shooting underwater, but I realize that might be out of reach for many due to the cost of equipment and scuba certification. But hold on just a minute! Someone else must've had the same thought, because they made a fabulous plastic bag for your camera. I know—it's pretty scary to think of trusting your equipment to a plastic bag, but read on.

ewa-marine (www.ewa-marine.com) has a great product that will take the cost and fear out of shooting underwater—to a certain extent. The bag (which is of course not the technical term for this *underwater housing*) in question will hold most modern cameras and even incorporates a flash if needed. I admit that the first time I placed my camera in the bag, I was praying to any and all gods that the thing wouldn't leak! But now I have done the testing for you, so you can have some fun.

NOFEAR

It takes a great deal of self-assurance as you begin to submerge your precious camera into the water, even with what is billed as a waterproof bag. Trust in the manufacturer, making sure you follow all instructions, but don't cheap out and try to use several Ziploc bags—it's not worth the risk!

First any body of water will do—the shower, a backyard pool, the ocean, or a lake. That's the fun part: You don't have to take it super deep; you just need to be comfortable in the water. I tried the bag out in a pop-up pool, a larger in-ground pool, and even in the bay, shooting Jet Skis waist high in the water.

My camera in the housing.

(Above) My favorite underwater portrait. Isn't photography great?! (Below) This Jet Ski shot could just as easily be a waterskier or a high diver.

The housing gets you as close to the action as you want while keeping everything dry.

The ewa-marine housing comes with a glass front that fits most lenses up to 82mm filter thread, depending on the model of housing you choose. It comes with a silica gel moisture-absorbing bag that is a must have to stop condensation, so don't forget to put it in.

After placing the lens/camera combination in the bag, you can either pre-focus or use auto-focus, depending on what your subject is. I found the auto-focus the easiest to use, as the pliable bag is very thick, and trying to manually focus while underwater is not ideal until you get more experienced with the equipment.

If you get the bag without the flash extension, never fear! I tried the pop-up flash on the Nikon D700; it worked well, and available light was great. Of course, you should try to shoot with big sun—high noon was ideal. This is one of the few times where shooting at high noon with the sun directly above you is helpful.

Working in a pool is wonderful because you can surface to make exposure changes pretty easily, without taking the camera out of the housing. I tried to keep my f-stop around 16–22 to get as much depth of field as possible. The housing has a small extension for your finger, so I found it easiest to position my finger on the shutter release before submerging, as everything compressed to the camera underwater, and it was harder to find it then.

A close-up of the index finger sleeve in the housing.

When you're shooting underwater, start with a subject who is fun and patient. I loaded a bunch of kids into the pool and had them swim toward me. We started above the surface, and on the count of three, we dropped under the water and the kids swam toward me. I found that the best distance for shots was around two feet in front of me on auto-focus, but depending on your light and ideas, it's all good stuff when you're having fun. This chapter is more of a teaser for you to see that there are other ways to make great portraits. You need to take it from here and see where it leads.

A fun portrait. Imagine the possibilities with your subject and different lengths of fabric.

This portrait is a wonderful moment of a child in full glee, the best kind of child portraiture.

If you are scuba certified, you can sit at the bottom of the pool with scuba tanks and let the action come to you. The wonderful aspect of underwater photography is that there really is no limit to your creative possibilities. You just need to work with people who have a fearless sense of adventure and add in

elements. Shooting with billowing fabric or dancers is fabulous, or maybe an engagement picture underwater with a watery kiss. Let your mind run free—and remember to hold your breath if you are not scuba certified!

> "*For half a century photography has been the 'art form' of the untalented. Obviously some pictures are more satisfactory than others, but where is credit due? To the designer of the camera? To the finger on the button? To the law of averages?*"
> —Gore Vidal

A very unique portrait that the subjects will treasure.

A simple change to black and white adds a timeless quality to the portrait.

Equipment Used

- Nikon D700

- 24–70mm f/2.8 lens

- 17–24mm f/2.8 lens

- ewa-marine underwater housing

Photoshop Modifications to Final Image

- Color balanced for blue cast.

- Desaturated for BW.

"Keep away from small people who try to belittle your ambitions. Small people always do that, but the really great make you feel that you, too, can become great."
—Mark Twain

17 Ultimate Portrait:

Group Panoramic

So, you get a call, and somebody wants a picture of 300 people in a courtyard. They want to see every head, and they don't have risers for people to stand on. Oh, and the picture is to be shot at dusk with available light. Anybody screaming yet? Well, don't panic. There is a way, and there is a man who does this type of portraiture all the time.

Meet Jim Ivey. The Central Photo Company specializes in panoramic group portraits, and Jim's family has been in business for more than a hundred years. They started out using 4×5 cameras, then moved to Cirkut cameras, and now, still using film, a Roundshot camera.

Cool as a cucumber, Jim Ivey five minutes before the shoot.

Group photography is an art, and not one to take on lightly. It requires intense organizational and people skills, as well as a grasp of perfect exposure. So saddle up and let's begin.

The key to a good group portrait is grouping. This seems self-explanatory, but it's where most people fail straight out of the gate. It is not as simple as standing on a tall ladder, telling everyone to look at you, and hoping for the best. A true group picture has symmetry and form and is a pleasure to look at. It does not matter whether the subjects are kids or adults, in a casual or formal setting; there is nothing worse than a picture that looks jammed up and unorganized.

"Group photography is an art, and not one to take on lightly."

First things first: Find out what you're dealing with and what the client's expectations are. In this scenario, we were going to be taking a picture of freshmen at a university before they went to their evening activities. They were to be dressed in jackets and ties but were not averse to sitting on the ground, as the picture was to be done outside, in front of one of the campus buildings. There were no steps or risers, but the client would provide a number of chairs—not enough for everyone to sit, but that's okay because you don't want everyone sitting in chairs anyway.

I was going to group them, and Jim was going to take the picture. From the time our subjects would turn up to the time we were to shoot would be about 15 minutes, and the sun was setting fast.

Checking and double-checking equipment, as failure is not an option when you have 15 minutes.

The chairs are curved to counter the distortion of panoramic cameras. They curve straight lines, so curves become straight!

The trick is to use your chairs to the best advantage and make sure that the tallest people are standing on the ground, not on the chairs. The back row in our shot consisted of two rows of chairs, back to back, and we left a gap large enough for a row of two people deep to stand. Next, we made two rows of chairs facing front, but we staggered them so that the back row was not directly behind the row in front of it. If you don't stagger the rows, the heads of the people in front will block the people behind them. So we ended up with four rows of chairs.

Chairs that will be stood on are back to back for extra stability.

A side view of the chair configuration. Note the space allowed for standing between rows, with the back row being the chairs on the far left.

Now for the fun part. We lined up our subjects by height. This is crucial to the picture being perfect. But do not call out people by height and expect it to be correct, because most people lie about their height—especially men. Often, asking the subjects to line themselves up by height works, as each can easily see whether the person next to him is taller, shorter, or about the same.

This process sounds incredibly time consuming, but you'll be surprised by how quickly you can accomplish it. Once the line starts forming, everyone gets on board with the process.

The big mistake most photographers make in a group shot when using chairs is putting the tallest people at the back and the shortest ones in the front. When using chairs, you want to fill the standing-room space with the tallest people. So take the tallest people and feed them in from either end to get a nice pyramid shape one row deep. Next, when that section is full, lead the line onto the back row of chairs, with the front of the line standing on the back row, and continue to fill until the back two rows are full. Now go to the end of the line, take the shortest people, and stand them in front of the tallest people.

"The big mistake most photographers make in a group shot when using chairs is putting the tallest people at the back and the shortest ones in the front."

When dealing with large groups, lining up by height is critical to the final outcome.

What you are left with is the medium to short people. Now fill out the last two rows of chairs with seated subjects. When that is full, you are left with a number of options. Depending on how many people are left, you can continue to make rows, but on the ground. The people in the very front row should be sitting flat on their behinds; the people in the row behind that should be sitting on their haunches. If needed, the third row should have people kneeling.

This picture was eight rows deep. I have never had to go any deeper than that, but that is because this was a panoramic, and I worked the length of the picture to its full advantage. The resulting picture has a smooth transition from front to back with no big height transitions.

NOFEAR

Someone always runs up at the last minute. Don't panic; just squeeze them in on the ends and keep smiling!

Here we see the smooth transition between our subjects, giving a cascading feel to the portrait.

(Pages 218–219) The finished panoramic is more than 20 inches in length—too long to show you here— so I have enlarged a section for you to see the sharpness and clarity of the image, with the red box in the entire panoramic being the area below that is enlarged.

The next group picture was not as neat, but it was a lot of fun. Every seven years, a small town in Pennsylvania has a reunion where all the towns-folk gather for a week of festivities. They start this with a group picture, which I can only describe to you as a controlled free-for-all.

People travel from all over the world to get back for this week, and the picture is coveted—especially a spot in the front row. The local police closed down the main street for 15 minutes, and I had just enough time to draw a line on the ground for the front row before the thousands of people descended on the street. To say that I had any real control would be a lie, but the people know from previous years where they needed to stand to be seen.

The key here is separation. You have to get the crowd to step back and away from each other to be seen. Everyone instinctually rushes forward to be as close to the front row as possible, but in fact the back row can be seen no matter how far back they go, as the camera is on a very tall tripod for this shot. This shot was over in a matter of minutes, and the traffic started moving through the town again as if we were never there.

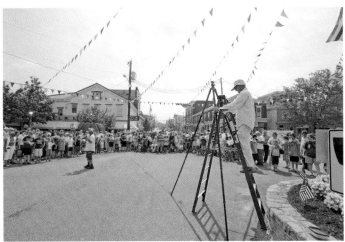

(Top right) Height and a steady hand are everything when you're shooting massive gatherings on a flat surface.
(Right) Thousands of people converging on the town center.

NOFEAR

Don't be afraid to use a bullhorn or another PA device to be heard. The crowds are usually friendly, but they still need to be controlled for everyone's safety.

One of the fun aspects of using a real panoramic camera is that if you are fast, you can run from one end of the group to the other, beating the camera and ending up in the picture twice. No Photoshop magic here, but pure hijinks and fun. To clarify, the camera actually moves, or pans the group, as it takes the picture. The film is pulled in one direction, and the camera moves in the other in perfect synchronization. Thus, as the camera moves from left to right, over 10 to 20 seconds, if you are one of the people on the far left, you can run faster than the camera as it pans left to right, and also appear on the far right of the image.

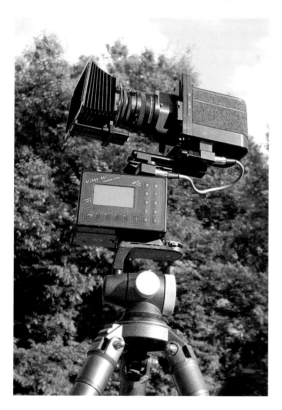

This is where the true panoramic comes into its own. Jim is able to control the exposure from one side of the picture to the other by adjusting the speed at which the camera moves. The shutter stays open, and the amount of exposure on the film is controlled by speed. This is essential when you are looking at group shots that are more than 50 feet long. Sometimes, due to the angle of the sun and the group's position, the left side of the group could be in shade while the right side is in the sun.

Panorama is a truly remarkable art, and due to the amazing software out there today, digital cameras are able to do a pretty good job of making a panoramic, even if you don't have a real panoramic camera. The stitch technology available lets you shoot large groups and seamlessly splice the images together. One word of caution: Make sure you leave quite a large amount of overlap room to allow for people moving, so when you stitch the images together, you have some wiggle room.

There are so many different combinations and formulas for arranging large groups like this that I couldn't possibly cover them all in one chapter. Suffice it to say that practice makes perfect. You have to adapt to your setting and your client's needs, and the more situations you encounter, the better you'll get.

(Left) A real panoramic camera that still uses film and gets the job done. (Pages 222–223) A perfect picture of Americana—the finished panoramic is more than 4 feet long.

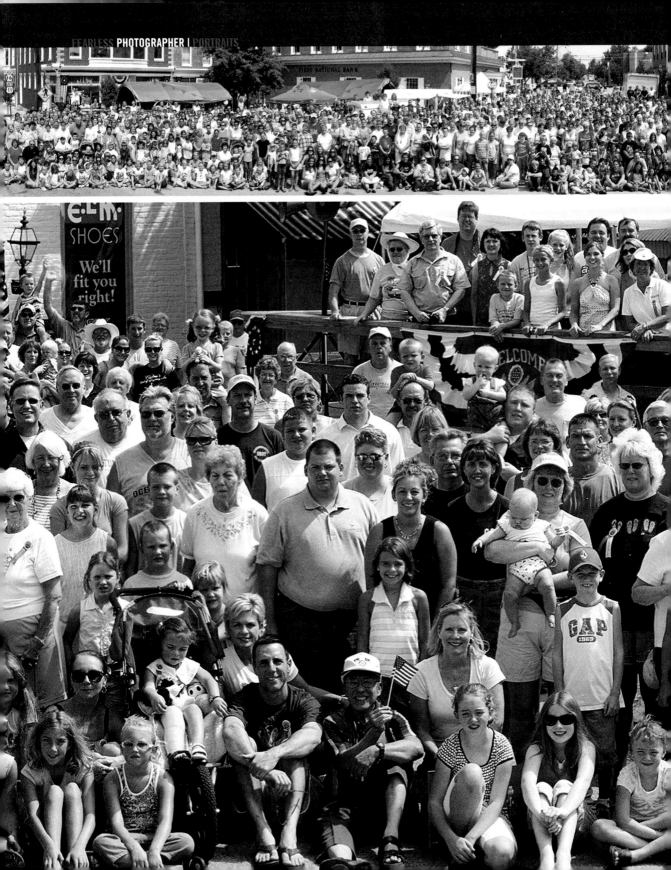

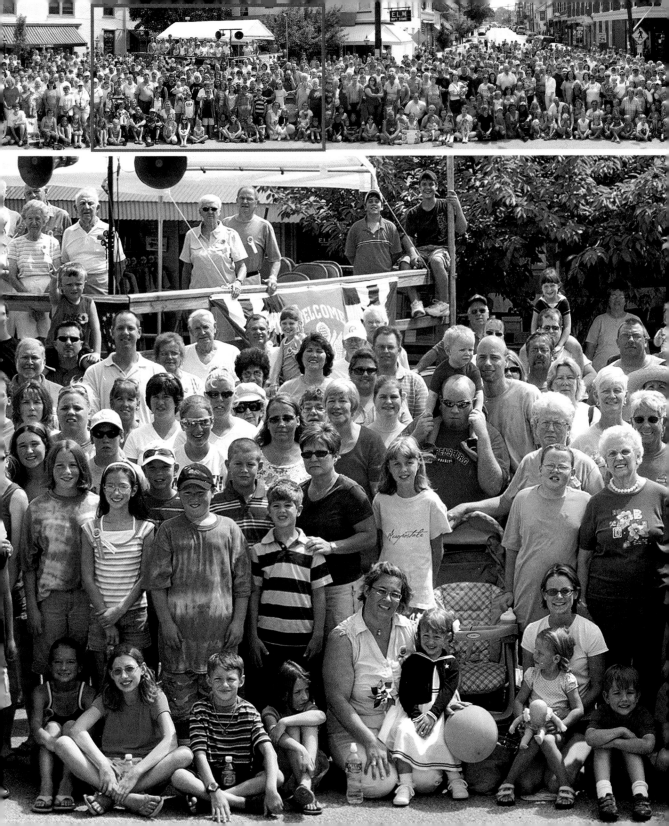

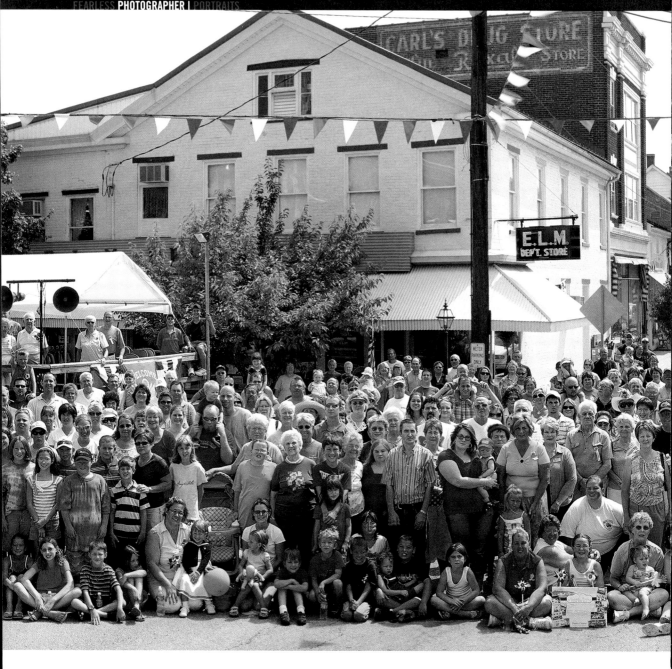

The strategy is similar in many ways when shooting groups in an 8×10 format. You can never be too high, so get a tripod that gives you what you need, along with a stepladder. If group photography is something that interests you, be sure to check out Jim's website at centralphotocompany.com and see how good the shots can be.

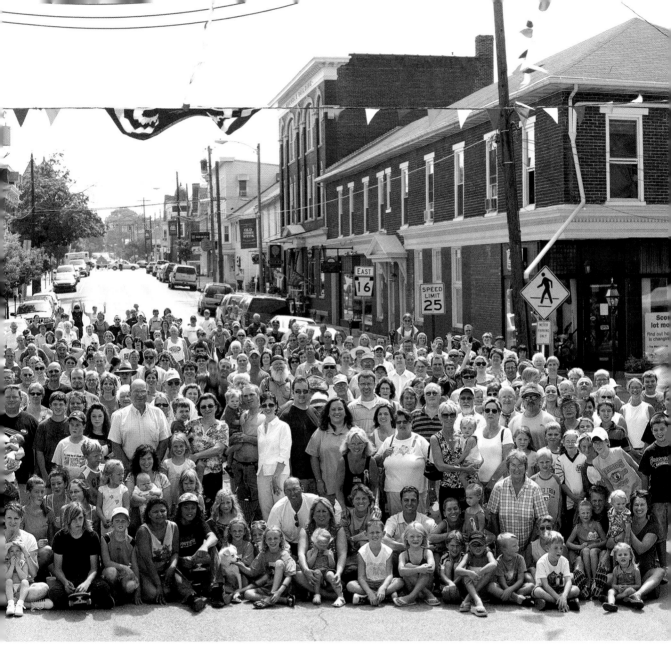

Finally, don't think that even when you work hard to get everyone spaced perfectly, you won't have a few blocked heads. I can't tell you how many times I have gotten everything perfect, only to see someone move out of frame at the last minute. In group pictures, there is always someone who doesn't want his or her picture taken.

Notice how the smart people move up the street so they can be seen—this is the far right of the image.

Equipment Used

- Roundshot camera

- Hasselblad 100mm f/3.5 planar lens

- Gitzo tripod with ball head and bubble level

Part VI

And in Conclusion...

Just when you think there's nothing else, I'm going to show you the horror of self-portraits and the beauty of beloved family keepsakes. If you have learned anything from me, it is to throw yourself out there, go with your instincts, and have faith that your fearless nature will attract like-minded individuals. I hope that you prosper in your endeavors. We need pictures to keep us in touch with our roots, to keep us in tune with our dreams, and to remind us of who we really are. So without further ado, I give you my self-portrait and a few personal favorites.

"*I myself have always stood in the awe of the camera. I recognize it for the instrument it is, part Stradivarius, part scalpel.*"
—Irving Penn

18 Self-Portrait: A Lesson in Humility

The dreaded self-portrait (silent scream)—every photographer should be forced to do this if for no other reason than to experience the other side of the lens. Many people have a tremendous fear of having their picture taken, as it is a frozen moment in time that can reveal more than is desired. An unflattering pose or bad lighting will always leave a bad taste in the mouth. How many people out there wish they could erase all the bad pictures of themselves from cyberspace and social-networking sites?

To truly understand portraiture, you have to live it, so be adventurous with your portrait; try different poses and angles. See what it feels like to do the things you ask your subjects to do. Who hasn't heard the line, "If it feels uncomfortable, it will look good in the picture?" So go ahead be a pretzel.

One thing I hate—and I mean really loathe—is the standard photographer-holding-the-camera shot, and I forbid you to do it unless it's totally insane and out there conceptually. If you want a self-portrait of yourself holding your camera to tell the world you are photographer, it better be because you are the new spokesperson for that brand of camera. Otherwise, be fearless and think outside of the box.

A self-portrait should teach you something about yourself. You, as the photographer, have complete control over the outcome, and you will choose the picture that shows you in the best light. What does that teach you about yourself and others when it comes to portraits? How brave are you?

The picture I have chosen for you to see of me is nothing more than my face straight out of the shower. Scrubbed clean, I stand before you with only the looks I inherited from my parents and the wrinkles I have earned with age. I lay myself out there naked and exhale as I take a long, hard look at myself.

"*Every morning you are handed 24 golden hours. They are one of the few things in this world that you get free of charge. If you had all the money in the world, you couldn't buy an extra hour. What will you do with this priceless treasure?*"
—*Source unknown*

My setup for this self-portrait was pretty simple, but you can be as complex as you wish.

I love my cable release, and not just for self-portraits.

A smile changes everything.

NO FEAR

Shooting a self-portrait as a learning experience is no time for vanity. Shooting yourself free of makeup and without Photoshop as a backup will teach you more about portrait photography than setting lights a hundred times will.

Do you like the way you look? Some people will say that they know what their good side is or what their strong points are, but more people will tell you what they hate. Look at the picture of my face and imagine that I am your client. How would you shoot me?

I used a light bounced off my bathroom ceiling to give me a big, soft light because I know a harsh light would just add unwanted years to my face. Are you that thoughtful in your lighting process? Do you really look at your clients' features and work out a lighting system that is best for them? Do you talk to your clients and listen when they joke about how they hate their hair or don't like their ears? These are the little things that will make all the difference in the finished product.

By honestly and objectively going through the process of shooting yourself, you will learn how it feels to be the subject. Every pose you hate and every frame you groan over will teach you more about the process than setting lights ever could. You will shoot yourself over and over again as vanity creeps in and you convince yourself that the next shot will be better. Don't just shoot and re-shoot—shoot and then study the results with more scrutiny than you would study yourself in front of the bathroom mirror.

Try to shoot your self-portrait without using Photoshop to fix things. Instead, learn to hold your head a certain way to minimize your extra chin, light your shot to remove the shadows in your eyes, and learn to smile and like what you see. After you spend a couple of hours getting to know yourself in front of the camera, you will be a better, more compassionate photographer—and if you are a little evil, you will also know how to make really unpleasant portraits!

"After you spend a couple of hours getting to know yourself in front of the camera, you will be a better, more compassionate photographer."

(Facing page) The real me. It's harder than it looks to have a natural look in your eyes when you're staring into your own lens.

Equipment Used

- Nikon D700

- Nikkor 105mm f/1.8 lens

- Bowens Pioneer SI battery-powered strobe

"*It is not merely the likeness which is precious…but the association and the sense of nearness involved in the thing…the fact of the very shadow of the person lying there fixed forever! It is the very sanctification of portraits I think—and it is not at all monstrous in me to say that I would rather have such a memorial of one I dearly loved than the noblest artist's work ever produced.*"
—Elizabeth Barrett Browning

19 Favorite Portraits:

A Final Word

So here we are at the end of the book, and I have one last thing to share with you. You need to have some favorite portraits that mean something to you. I'm talking about a picture that reminds you of a different time and place, that makes you smile or even cry. There are more refrigerators covered with pictures held in place by magnets, more crumpled-up photos in wallets than can ever be publically viewed. We crave a connection to memories and people long gone from our lives, to people in distant places and our dearest friends.

Over the years, a few images have brought me to great emotion, and I want to share them and encourage you to think about your own special portraits. When you reflect on how your personal portraits make you feel, think about how the images you create impact your clients. Every image is unique in its inception, but more so in its ability to evoke true emotion and a permanent connection with the viewer.

This is a picture of my grand-pop; he lived to be 104 and had seven children and too many grand-children and great-grandchildren to mention. He lived a full and wonderful life married to my grandmother, and his greatest regret was that she died before him and he was left alone. He was heartbroken and lived every day hoping that it was time for him to join his beloved wife. He carried on every day, going through the same daily rituals in his home as if she was still there and grumbling at the attention his family afforded him. His grown children watched over him and cooked meals, washed his clothes, and generally cleaned up, and all the while he rolled his eyes, baked bread, and told stories of bygone days until he put himself to bed and waited for the next day to do it all over again, praying that it would be his last so he could reunite with his beloved.

This picture is of him sitting in the kitchen eating his dinner, at the same table he had when his wife was alive. His love of familiar things and tradition was a constant until his death. When I look at this picture, it reminds me of my childhood, when all my cousins and aunts and uncles sat at the dining-room table with him at Christmas, and he presided over the festivities from the head chair. I took the picture on the last occasion I saw him before his death, and it is filled with a bittersweet emotions, as he is alone yet resilient. I miss him.

Never without a hat, and even though he's alone, he's still using a crystal dish to hold his condiments.

"*I hear and I forget, I see and I remember. I do and I understand.*"
—*Chinese proverb*

Always remember that our parents have been there and done that, and they are just keeping up appearances for us.

These three pictures of my mother are my favorites because they were taken during a very out-of-character but candid moment when my mother let loose in front of my camera. As children, we see our parents in a very different light and form opinions as we go through life about how uptight our parents are. Even though we know they have a sense of humor, they are in the same category as teachers—we assume they don't have normal lives and don't know anything!

I was taking pictures of my children and my niece, and I asked my mother if she would like to join in. After some goading from her grandchildren, she decided to show them what she could do and did her best rock-star impression. The humor is in the fact that she is dressed conservatively, as is her way, but is behaving badly. Maybe there is more to my mother than meets the eye? The preconceived notions that we have of our parents are based on our childhood ideas that our parents were never young, never had fun, and were put on the planet to ruin our lives. These pictures put all those ideas into a tailspin and leave me wondering what I don't know, which is why they are some of my favorites.

So much is conveyed in this image. Her balloons have deflated because she's been there for so long. Fragile yet defiant, she is facing another day.

This picture is of my daughter. It is not a happy picture, but a poignant portrait of resignation to a situation over which she has no control. She has a disease, ulcerative colitis, that has no cure and has some very nasty symptoms. You learn to live with it and control it, but sometimes it rears up and takes a toll on your body that is so horrendous that you are hospitalized. She has been a regular at Children's Hospital, and every time she faces it with a stoic attitude and hopes for a shorter stay than six weeks.

As a parent, there is nothing worse than watching a child suffer. You would trade places in a heartbeat, give your life to end the suffering, and you learn in the process that your children are stronger than you. The morning I took this picture, my daughter was on week three of her stay, and I was on week three of sleeping in the vinyl chair in her room. The sun started to rise, and as the light shone through her window, she opened her eyes; wringing her hands, she faced another day. I keep this photo as a reminder of the power of the human spirit and her grim determination under fire. She is doing well.

This picture is of trust. This is my best friend, and this picture was taken before he became my better half. For work he dresses very conservatively and is not comfortable in situations that don't require a suit and tie. Any hint of impropriety has him running for the hills, and I still don't know what he sees in me. He looks and I leap, yet we are blissfully in love.

One thing he hates is having his picture taken. Like me, he is a photographer, but to this day there are fewer than a handful of people he has ever let take his picture, and he forbids portrait sessions. So I convinced him to let me take his picture, and it took weeks of pushing and planning to get him to commit to a date. When he was out of excuses, I made a series of pictures.

The reason this picture is so powerful is because it is the moment when he had to let go and trust that I would not take an unflattering picture. I asked him to reach up and undo his tie—a simple request, but one that hit at the core of who he is, a conservative man. As he raised his hand to undo the tie, he knew I had him, and I got one frame before the moment passed. It has remained my favorite throughout our years together, even though now I've photographed him many times.

Find your favorites and understand how they make you feel, and then you will truly understand the power of portraiture and the great gift you can bestow on another with your art.

Captured in a single frame— a timeless moment of trust.

Index

S

WE'VE GOT YOUR SHOT COVERED.

New Releases

**A Shot in the Dark:
A Creative DIY Guide to
Digital Video Lighting on
(Almost) No Budget**
1-4354-5863-X • $44.99

**Fashion Flair for
Portrait and Wedding
Photography**
1-4354-5884-2 • $34.99

**Fearless Photographer:
Portraits**
1-4354-5824-9 • $34.99

**Picture Yourself Making
Creative Movies with Corel
VideoStudio Pro X4**
1-4354-5726-9 • $29.99

**Complete Digital
Photography,
Sixth Edition**
1-4354-5920-2 • $44.99

**David Busch's Mastering
Digital SLR Photography,
Third Edition**
1-4354-5832-X • $39.99

**The Linked Photographers'
Guide to Online Marketing
and Social Media**
1-4354-5508-8 • $29.99

**Picture Yourself
Learning Corel PaintShop
Photo Pro X3**
1-4354-5674-2 • $29.99

**Fearless Photographer:
Weddings**
1-4354-5724-2 • $34.99

**Photographs from
the Edge of Reality**
1-4354-5782-X • $39.99

**Killer Photos
with Your iPhone**
1-4354-5689-0 • $24.99

**Photo Restoration and
Retouching Using Corel
PaintShop Photo Pro,
Second Edition**
1-4354-5680-7 • $39.99

New from #1 Bestselling Author David Busch!

To learn more about the author and our complete collection of David Busch products please visit www.courseptr.com/davidbusch.

David Busch, Your Complete Solution

**David Busch's Canon
PowerShot G12 Guide
to Digital Photography**
1-4354-5950-4 • $29.99

**David Busch's Sony α SLT-
A55/A33 Guide to Digital
Photography**
1-4354-5944-X • $29.99

**David Busch's Nikon
D3100 Guide to Digital
SLR Photography**
1-4354-5940-7 • $29.99

**David Busch's
Compact Field Guide
for the Nikon D3100**
1-4354-5994-6 • $13.99

**David Busch's Canon EOS
60D Guide to Digital SLR
Photography**
1-4354-5938-5 • $29.99

**David Busch's
Compact Field Guide
for the Canon EOS 60D**
1-4354-5996-2 • $13.99

**David Busch's
Compact Field Guide
for the Canon EOS 7D**
1-4354-5878-8 • $13.99

**David Busch's Nikon
D7000 Guide to Digital
SLR Photography**
1-4354-5942-3 • $29.99

**David Busch's
Compact Field Guide
for the Nikon D7000**
1-4354-5998-9 • $13.99

**David Busch's Canon EOS
Rebel T3i/600D Guide to
Digital SLR Photography**
1-4354-6028-6 • $29.99

**David Busch's Compact
Field Guide for the Canon
EOS Rebel T3i/600D**
1-4354-6032-4 • $13.99

**David Busch's Sony α
DSLR-A580/A560 Guide
to Digital Photography**

COURSE TECHNOLOGY
CENGAGE Learning
Professional • Technical • Reference

Our comprehensive list of digital photography books can be found
online at **www.courseptr.com**, by phone at **1.800.354.9706**, and
at Amazon, Barnes & Noble, and other fine retailers nationwide.